food

edited by john knechtel

an alphabet city media book
the mit press cambridge, massachusetts london, england

MIT Press books may be purchased at special quantity discounts
for business or sales promotional use. For information, please email
special_sales@mitpress.mit.edu or write to Special Sales Department,
The MIT Press, 55 Hayward Street, Cambridge, MA 02142.

Cover photographs:
Details from the series *Smarties* (2004) by Christine D'Onofrio.

This book was printed and bound in China.

ISBN: 978-0-262-11309-0
ISSN: 1183-8086

10 9 8 7 6 5 4 3 2 1

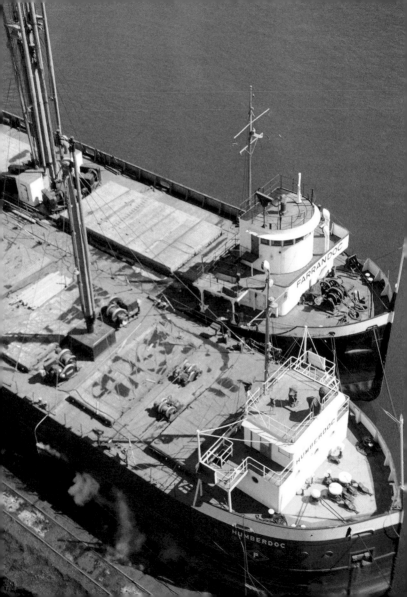

This photograph was taken by my father, Kent Knechtel, in April 1946. A young chemist at the Canada Starch Company plant in Cardinal, Ontario, he was standing at the top of the company's silo looking down on the *Humberdoc* and the *Farrandoc* unloading prairie corn. They had made the journey here via the Great Lakes to the old St. Lawrence canal system. Although these small canallers built in the 1930s were still working vessels when my father took the picture, their days were numbered. Such is the life cycle of infrastructure. The St. Lawrence Seaway opened in 1959, admitting seagoing vessels to Ontario's inland ports, and by 1967 the *Humberdoc* and the *Farrandoc* were scrap.

The village of Cardinal is on the north shore of the St. Lawrence River, downstream from Ogdensburg, New York. The American and Canadian sides are so close together there that in winter when the ice is thick you can walk right across into another country. As a border town, Cardinal benefited economically whatever the state of relations—from war to peace to economic cooperation—between the US and Canada.

It all started in the eighteenth century when the British built a canal system to counter the American military threat, extending the area's access to distant markets. Later, to reward the United Empire Loyalists, refugees from the American War of Independence, the British surveyed the Upper Canada wilderness along the St. Lawrence River and converted it to land grants. In 1790, on one of those lots, Captain Hugh Munro built a mill; in 1858, W. T. Benson bought the mill and established the first corn-grinding operation in Canada, with a capacity of 200 bushels per year. One hundred years later that had grown to 12,000 bushels, and by 1959 the circuit of trans-border exchange was completed when the Canada Starch Company was sold to an American multinational company.

The Cardinal plant can be understood as an equation that must be balanced. In the 1950s the basic factors to the left of the equal sign were infrastructure, corn, energy, and technology; to the right were profit and paychecks. Today the plant is tied into the virtual canals of the international commodity markets where a favorable cost differential between high fructose corn syrup (HFCS) and sugar determines its profitability. HFCS, first engineered in Japan in the 1970s, has become the cheap sweetener of choice for food manufacturers worldwide. My father and his colleagues used Japanese research, German machinery, and American capital to help them build Cardinal's HFCS plant, an extension to the original corn mill.

To a generation that had lived through the Great Depression and World War II, the overriding purpose of public and private enterprise was economic growth and the jobs that went with it. By this measure, the technological development of Hugh Munro's mill has been an unqualified success.

There are thousands of Cardinals across North America, a continental army of food-processing plants. They are so familiar as to be

invisible. We are now beginning to question this landscape, and can see that our food production system remains structurally blind to ecological and social imperatives. Designed to create wealth and distribute cheap food, the system has been slow to factor in its responsibilities for the health of the land and the people. Cardinal exemplifies this paradox. It is perfectly adapted to its capital purpose—to generate the optimal level of jobs and wealth. But the success of HFCS as a key component in mass-marketed, cheap, sugary food has brought with it social costs.

Today we're faced with a challenge just as daunting as that faced by the postwar generation. We must recognize that our food production system was conceived in different times; what worked then is inadequate, even dangerous, now. We need to reimagine and redevelop our food production capability to guarantee and maintain new factors on the right side of the equation: pesticide-free waterways, sustained genetic diversity, low fuel consumption, thriving farms, employment, and nutritious food—in short, a sustainable, productive landscape. We do not have the option to start from scratch. The current food production system is too massive, entrenched, and profitable to be disassembled. Our strategy in this epic endeavor must be to co-opt and adapt what already exists.

We must work through the contradictions built into the structures we inherited from the twentieth century and find our way to a rebalanced food production system, one that respects the land, water, and air we depend on, generates prosperity without waste or harm, and sustains the health of people everywhere.

—JK

Zvezda Service Module on the
International Space Station, June 8, 2003

the rise
of the
gastronaut
jane levi

> …he had had no plates, spoons, forks, or napkins aboard. He had
> stretched out his hand to the food containers and taken the first tube
> there. On the ground it had weighed about 150 grammes but in space
> it was weightless. Inside the tube there had been a puree, which he
> had squeezed out into his mouth as if it had been toothpaste. For his
> second course he had had a meat and a liver *pate,* and had then
> washed all this down with some black currant juice, also out of a tube.
> —Yuri Gagarin and Vladimir Lebedev, *Psychology and Space*

So proceeded the first human meal in space, eaten by the Russian cosmonaut Gherman Titov on August, 6, 1961. Yuri Gagarin's flight into orbit a few months earlier marked the beginning of the space race, but if Titov hadn't proved that eating in weightless conditions was possible, human spaceflight would have been limited to day trips. No wonder the tube shot to fame as the ultimate in futuristic eating. In fact, tube feeding was hardly space-age even in the 1960s. These semiliquid, semisolid comestibles had first been developed in the 1940s and '50s for high-altitude and high-speed fighter pilots, and their use in the space program was a convenient re-use of existing technology. As journeys into space extended to durations of days and months, space food developed in a number of ways, from tubes and cubes of unrecognizable, vile-tasting mush to more familiar-looking and flavorsome food in cans and pouches. Now, as missions lasting years are being contemplated, space food is set to launch into a new phase that emphasizes self-sufficiency. Mirroring current earthly concerns about sustainable agriculture and local produce, onboard food production will be an essential component on the journey to Mars.

The creation of onboard farms and kitchens certainly has the potential to make dining in microgravity more appealing. Throughout its development there has been conflict between technological efficiency and culinary excellence in space food. Some programs treated food as an inconvenient necessity, while others saw it as a critical

factor in well-being, morale, and performance. Were the astronauts Air Force daredevils, focused on their mission and impatient with the time wasted eating during short-term space *travel*? Or were they intellectuals, experimental astroscientists examining every aspect of long-term space *living*, who hence saw food as a primary consideration for the success of the mission? The quality of the food was highly dependent on the answer to these fundamental questions of approach.

When you consider the colossal budgets for space development in the second half of the twentieth century, it is surprising how bad the early food really was. The space programs were at the cutting edge of engineering and technological achievement, working with the best of everything, and many of the inspired inventions that emerged as solutions to space-travel-related problems have famously found their way into the daily lives of Earth dwellers: water purification systems, Teflon, ultra-lightweight textiles, digital cameras. A review of food-related space inventions is less impressive. Tang, rehydratable mashed potatoes, and freeze-dried ice cream are classic examples, and they can hardly be said to have improved our meals here on Earth, or sparked anything more than novelty interest.

It now seems extraordinary that a project focused on manned flights should have treated the human aspects of these grueling journeys as an afterthought, but in the US race to the moon the whole business of storing food, carrying food, eating food, and clearing up after eating was viewed as a major inconvenience, adding awkward weight and bulk to a tiny and already overloaded capsule. Food as an essential factor in the astronauts' comfort and psychological well-being was not given a high priority. One researcher in the late 1960s commented dismissively that "Interviews with each astronaut regarding his food likes and dislikes have proved to be of little value"

Space Shuttle food tray containing packets of dehydrated food and beverage, November 28, 1983

When you consider the colossal budgets for space development in the second half of the twentieth century, it is surprising how bad the early food really was

(Vishniac and Favorite 278). When astronauts complained about their meals, their comments were met with irritation and a demand for "concrete evidence," perhaps using obscure tools like the "Arthur D. Little Flavor Profile Method" (Sauer 56). Even in the 1980s it was being suggested that crews should think of their flights as "'camping trips,' where inconvenience is tolerable because duration is limited" (Sauer 20). Only in the last ten years have US nutritionists stated categorically that "Highly acceptable foods can play a primary role in reducing the stress of prolonged space missions" (Perchonok and Bourland 916).

From the beginning, the Russians took a different approach, perhaps because one of their objectives had always been to establish a long-term presence in space (on space stations), leading them to take seriously the realities of actually living far from Earth. Yuri Gagarin himself co-authored a book with the space psychologist Vladimir Lebedev called *Psychology and Space,* demonstrating how fundamental such psychological considerations were to the Russian program. The complexities of the dinner question were given their due importance: "Having a good meal is, of course, something more than downing one's food. It's a complicated process combining physiological and psychological elements. Even in a short flight tasty, favorite dishes can provide the astronauts with relaxation during their strenuous work" (27). The Russian cosmonauts' tastes, preferences, and gastronomic opinions were taken into consideration when foods desirable for longer-duration flights were being developed. Vacuum-packed meals would only keep for a few days, and to preserve food longer, lyophilization (dehydration and compression) would be necessary. "It is only fair to say that this is not delightful a prospect [sic], but then science does call for sacrifices…" (Gagarin and Lebedev 28). US astronauts were not permitted such freedom of expression about their menus for several decades.

Long before space travel became a scientific reality, writers of fiction had given creative consideration to the practicalities of eating during journeys in space. Cyrano de Bergerac's hero in *Le Voyage dans la Lune* (1657) is one of the first and most fortunate space diners. He sups on vapors and breakfasts on the ultimate in convenience food: freshly shot larks that fall to the ground already plucked, roasted, and seasoned. Two hundred and fifty years later the heroes of H. G. Wells's *The First Men in the Moon* (1901) took advantage of the scientific developments of their age by loading a selection of tinned, compressed foods and essences into their lunar sphere. Jules Verne's straightforward idea, in *De la Terre à la Lune* (1865), that the crew simply "sat down to table and breakfasted merrily" in their rocket remains one of space fiction's most compellingly human scenes. In reality, this vision of natural, convivial living without extreme technological intervention has proved very difficult to achieve. Oddly, once the space age began, fictional depictions moved even farther away from the realm of possibility. Perhaps to avoid the uninteresting reality of space food, most depictions in books and films are sheer fantasy; bright blue wine is served during dinner in *Star Trek,* and talking cows offer steaks from their own bodies in *The Restaurant at the End of the Universe.*

The ideas coming out of real-world space programs were often even more fantastic. In the late 1960s US researchers investigated the possibility of using bacteria as a source of food. They chose *H. euphorba,* which feeds on human urine, converting urea into edible protein; the scientists suggested that after being processed into a dry tasteless substance it could be flavored and made into biscuits or crackers. The mind boggles at the thought of hungry astronauts eating urine cookies. Fortunately, early trials were not successful: the substance caused nausea, vomiting, vertigo, and diarrhea. The experiment

was abandoned. Notably, the Russians had abandoned similar ideas at a much earlier stage, recognizing the "negative psychological effects" (Vishniac and Favorite 263–64).

One US researcher proposed building an edible spacecraft. He suggested that food with high carbon content could act as an effective heat or radiation shield; or that expendable parts such as fuel tanks, instrument casings, and launch facilities could be made from food. How they would taste after performing their primary function was not mentioned. Inspired by Japanese practices in World War II, he also proposed that clothing fibers could be made from edible materials such as soybeans, egg whites, and chicken feathers. In the panel discussion that followed the presentation of this paper, it was suggested that astronauts should be sufficiently motivated by the honor of selection to put up with this or any other innovative food solutions scientists might come up with (such as a liquid formula diet), no matter how disgusting they were. The astronauts' responses to these proposals were not recorded, but there do not appear to have been any live trials.

The astronauts were not so lucky with other experiments. Technologists developed new extreme desiccation and compression techniques, allowing them to feed the *Mercury* astronauts in the early 1960s a range of identical bite-sized dried and compressed cubes, which rehydrated when chewed. Flavors included bacon, cheese and crackers, toast, peanut butter, and fruitcake, but it is doubtful that you'd be able to tell which one you were eating if the label had fallen off. NASA scientists were extremely worried about the possibility of crumbs—which could not easily be cleaned up—damaging equipment, clogging vents, and being inhaled by astronauts, and in an attempt to solve this problem various experimental coatings were applied to the cubes. Gelatine, starches, fat emulsions, and hydrogenated oils were

all tried, but they either flaked, stuck together, or caused digestive problems. The Russians, on the other hand, decided to accept the inevitability of crumbs and instead think about how to collect them. The cosmonauts were therefore allowed fresh bread, salami, and candied fruit jelly, either made in or cut into bite-sized pieces, and given a small vacuum cleaner to clear up the worst of the mess.

The contents of both the tubes and the cubes had an unpleasant texture, disagreeable mouth-feel, and low palatability. Much of the food returned to Earth uneaten, and the astronauts lost weight. They further testified that conditions in space affected their senses of smell and taste, leading to cravings for stronger, spicier foods than they would have enjoyed on Earth. The precise effect on any individual is hard to predict, and because the food is chosen before departure astronauts have often been stuck with choices they no longer find appetizing. Given that astronauts have a 44 to 67 percent chance of suffering from several days of space motion sickness, and that one of the side effects of weightlessness is increased flatulence, it is perhaps fortunate that the sense of smell is diminished. Nonetheless, as missions grew longer through the late 1960s and early 1970s, and many other adverse physical effects of space travel became apparent, it also became increasingly clear that crews had to eat well. Even though it can't be easy to tempt the palate in the smelly, stuffy, claustrophobic confines of a space capsule, flavor and palatability were recognized as critically important criteria for space food.

Nutritionists argued that the solution was to make the astronauts' meals more familiar and appetizing, providing the variety of textures, appearances, and sensations we naturally crave in our food. The Russians had achieved this by turning to an existing, highly flexible technology: a large proportion of Russian space food was canned, and could be heated on board; even the earliest Soviet space stations had

One US researcher proposed building an edible spacecraft. He suggested that food with high carbon content could act as an effective heat or radiation shield; or that expendable parts such as fuel tanks, instrument casings, and launch facilities could be made from food.

Apollo Soyuz Test Project crewmen have a meal during a training session at the Jonhson Space Center, February 25, 1975

small ovens or warming trays. Refrigerators were also provided to store fresh produce. The Americans, driven by their ongoing concerns about bulk and weight, were keen to find new, cutting-edge solutions. To make the food itself lighter, and to avoid taking up valuable space with kitchen facilities, they developed dehydrated meals in pouches that could be reconstituted with waste or recycled water. The early attempts were revolting: initially only cold water was available and as a result one of *Gemini*'s major discoveries was that astronauts don't like cold instant mashed potatoes. Even by the late 1960s and early 1970s when hot water began to be provided on the *Apollo* spacecraft and Skylab, these meals were only marginally more appealing. "'I found that if I reconstituted the peas, the beans and the asparagus early, and then reheated them,' Pete Conrad quipped, 'I still didn't like them, but they were a lot easier to choke down than when I added the hot water, shook up the bag and then tried to get them down'" (Crouch 246). Meanwhile the Russians were apparently tucking into meat croquettes, caviar sandwiches, and fresh fruit.

When the impact of good food and conviviality on human performance and physical well-being was at last recognized, the lot of astronauts began to improve. Space food technologists stopped trying to lead the way with innovative food solutions and instead looked to existing Earthly options. Thermostabilized (heat-sterilized) food in cans or pouches provided the astronauts with ready meals that didn't need to be rehydrated and massaged into life, and the first of these, on *Apollo 8* at Christmas 1968, proved to be a genuine boost to morale. Jim Lovell said all the right things on the live link with Earth: "It appears that we did a grave injustice to the food people. Santa Claus brought us a TV dinner each which is delicious: turkey and gravy; cranberry sauce; grape punch—outstanding" (*Apollo*). The most enthusiastic responses to food during Apollo missions were for

exactly this sort of comfort food; TV dinners to remind the astronauts of home.

Gradually, other classic American dishes like frankfurters, meatballs, and chicken à la king found their way onto the US menu, and the number of complaints began to fall. By the 1980s the NASA bill of fare included increasing quantities of ready-packaged foods, recognizable to anyone as "normal" meals.

Before the cost-cutting forced on them by the collapse of the Soviet Union, the Russian Space Agency sent up caviar and pâté for New Year's and birthday celebrations, delicacies rumored to have been washed down with bootleg vodka or cognac. For everyday eating, classic Russian favorites were supplied. Cosmonauts could choose from cabbage soup, rye or black bread, beef stroganoff, beetroot soups and salads, *tvorog* (cottage cheese with nuts), spiced and pickled perch, and buckwheat gruel. Fresh apples, onions, and garlic were delivered along with scientific equipment in *Progress* resupply vehicles. Cosmonauts were also known to eat the experimental plants they had grown in onboard experiments, especially onions: perhaps these helped to satisfy the craving for strong flavors as well as fresh food. French astronauts visiting the Russian Mir space station and later the US Space Shuttle set a new standard for space cuisine by bringing along canned gourmet feasts: boned quail in wine sauce, lobster, Alsace-style jugged hare, duck confit with capers, pigeons in wine-and-tomato confit, *pâte de fruit,* and cheese. The Chinese developed "Chinese food for Chinese astronauts," offering Szechuan *gong bao* chicken, shredded pork with garlic, eight treasure lotus porridge with lotus seeds and longan, and—appropriately—moon cakes.

Now that we are entering the next phase of manned space exploration, the fantastical and the actual have once again begun to collide. On Earth many people are increasingly challenging the

industrialization of our food supply, and turning to organic, home-grown, and natural solutions. Meanwhile, NASA is working out how to support a minimum two-year mission to Mars. The sheer impossibility of pre-packing enough food and keeping it for so long has led to the conclusion that self-sufficiency is the only way for such a mission to succeed. Once again, the example of the Russians in space, eating their own freshly grown produce, has shown the way. The Mars astronauts will grow lettuce, tomatoes, spinach, herbs, radishes, peppers, cabbages, and strawberries on board, and plans are afoot to hydroponically farm soybeans, wheat, rice, peanuts, and beans on arrival. Scientists from the European Space Agency have been working with the famous French chef Alain Ducasse to develop recipes from these ingredients. The technologists have a new set of plans, including growing meat from muscle cells in cell-culture fluid, and using high-protein spirulina algae as a food source. Whatever the final menu turns out to be, it is clear that rather than the heroic man-machines astronauts needed to be in the twentieth century, those of the twenty-first will have to be farmers and cooks. Throughout most of its history, space food has proved to be a technical success and a culinary failure. In the future, as interplanetary travelers themselves take control of the farm as well as the kitchen, a new space gastronomy worthy of the name may emerge.

Douglas Adams (1980)
*The Restaurant at the End
of the Universe*
London: Pan Books

Apollo DVD (1999)
Allegro Corporation, disc I

Cyrano de Bergerac (1965)
*Other Worlds: The Comical History
of the States and Empires of the
Moon and the Sun*
London: Oxford University Press

Tom D. Crouch (1999)
*Aiming for the Stars: The Dreamers
and Doers of the Space Age*
Washington, DC: Smithsonian
Institution Press

Yuri Gagarin and
Vladimir Lebedev (1970)
Boris Belitsky, trans.
Psychology and Space

Michele Perchonok and
Charles Bourland (2002)
NASA Food Systems: Past, Present,
and Future
Nutrition, vol. 18, no. 10

Richard L. Sauer, ed. (1985)
*Food Service and Nutrition for the
Space Station (NASA CP-2370)*
Washington, DC: NASA

Jules Verne (1865)
Round the Moon
London: Ward, Lock & Tyler

W. Vishniac and
F. G. Favorite, eds. (1969)
*COSPAR Life Sciences and Space
Research VIII*
Proceedings of the Symposium on
Nutrition of Man in Space, Prague

H. G. Wells (1993)
The First Men in the Moon
London: Everyman

mother lode
rebecca duclos
david ross

Gjelder he
Svalbar

Inside a sandstone mountain on a remote Arctic island near the Norwegian village of Longyearbyen, the Svalbard Global Seed Vault is taking shape. Featuring local polar bear protection, blast-proof doors, motion sensors, meter-thick steel reinforced concrete walls, and double air locks, the Seed Vault will be the safest cold storage agricultural gene bank in history.

Construction equipment outside Svalbard Seed Vault tunnel, May 2007

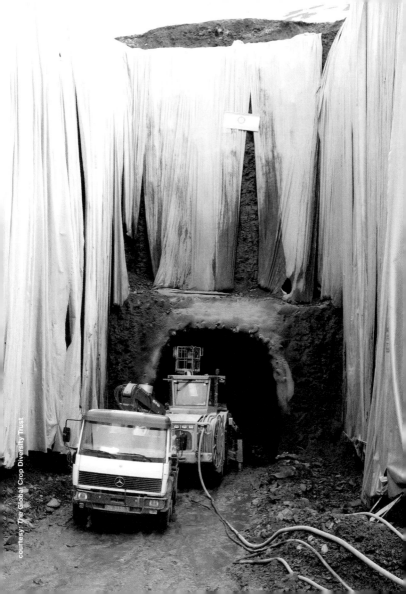

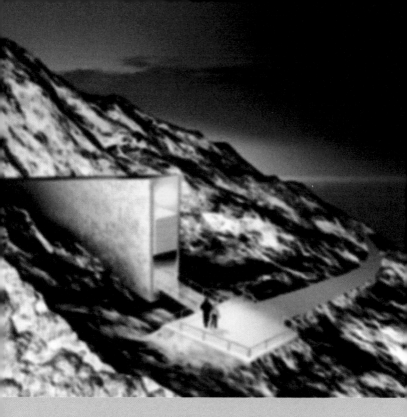

The Svalbard Seed Vault is a kind of sideways silo, its horizontal thrust boring lengthwise toward the mountain's core. Hewn from a geological mass rather than asserting its own built shape in exterior space, the Seed Vault design is driven by a logic of infiltration rather than exaltation. This formal inversion of upright architectural geometries gives Svalbard an unusual place among building typologies traditionally developed for agricultural storage.

North American grain silos and elevators were lauded by Le Corbusier as early-twentieth-century exemplars of the perfect union of form and function. Images of silos graced nearly every page of Le Corbusier's section on mass in his 1923 manifesto, "Three Reminders to Architects." Some eighty years later this skyward-reaching icon, which once symbolized a landscape of intensive agricultural production and consumption, has been turned on its side and buried.

The *Cornish Point* and *Admiral Cochrane,* Montreal Harbour, Quebec, 1920

The seeds in the Svalbard vault will be taken out of agricultural circulation and safeguarded as dormant currency within an imagined economy of survival. Just as the Pyramids' network of tunnels stored supplies for the next life of Egyptian kings, the Svalbard Vault holds for us a wealth of botanical DNA. Thus attached to the idea of an agricultural afterlife, the seeds become genetic guarantors for a potential post-apocalyptic landscape. Proceeding without the kingly corpse, we are nevertheless building our own global storehouse of futuristic pharaonic food.

A womb for the planet, the Seed Vault will eventually contain enough genetic material to ensure that global crop diversity can be maintained or restored in an unpredictable future. Nestled within Svalbard's two interior vaults, hidden deep inside rock penetrated by just one tunnel opening to the exterior, three million seed samples will be carefully stored in individual foil packs. Representing every extant biological specimen needed for plant breeding and propagation in the future, the Svalbard collection will be the living mother lode of botanic matter in repose.

Illustrations: by David Ross based on original design by Barlindhaug Consult AS

chinese
american
mei chin

translated into chinese by lei bo

中國処南瞻部州，其烹飪之精，甲于天下，世以爲罕有其匹者。當三王五帝之時，海西各部尚以杵碎肉，茹其毛而飲其血，中國諸賢則已斤斤論較于鹿脯蟹黃、菜蔬粟餅之優劣短長，其語録心得，傳諸丹青者，在在皆是。世所共知，無須贅論。然亦有世人習焉不察者：芙蓉之彩蛋、蘑菇之雞片，乃至以五色粘連之醬汁覆于金油深炸之麵條，其妙想覃思，皆肇端於中華故地。延至今日，有泰西舶來之雞精味素者，能於釜中化朽爲奇，是故中國萬家庖廚，無不以古色甌瓶慎而盛之，又有巧者制醬，名曰"千島"，偶一試用，天下靡然向風。於是屠剝湯煮之地，至於華彩洋洋矣。

有數章未刊之中國舊典，歷代無識其詳者，而近日漸為人所知。如《論語》中孔子假鹽梅烹調之肉以喻邦國之政，又如李太白作長歌以挽鳳尾酒。好事者因蒐集之而校勘刻行，題曰"辣與酸—中華庖廚呻吟寶典禁書集"，片言隻字，皆足珍貴，將使讀者漸語烹調之三昧，而對此遼廓深玄之故土有心知神會焉。

The Chinese are considered to have one of the greatest cuisines in the world. While Western men chewed raw meat that they had clubbed, the Chinese were writing cookbooks that debated the relative values of venison, crab roe, vegetables, and pastries. But the Chinese have also been responsible for such delicacies as egg foo yong, moo goo gai pan, and deep-fried noodles topped with goop. MSG graces every Chinese kitchen in a canister the size of an ancestral urn, and the condiment of choice is Thousand Islands dressing.

Now a selection of previously unpublished excerpts from Chinese historical classics has come to our attention. Until recently, we did not know that the *Analects* included a metaphor made by Confucius of the relationship between state order and sweet-and-sour pork. Nor were we aware that the poet Li Bai wrote an elegy to mai tais. Now available for the first time in print in the volume *Hot and Sour: The Suppressed Legacy of Classical Chinese Kitchen Trash,* these gems serve to enhance our culinary comprehension of this vast and complicated land.

《論語》選段：

衛靈公去國南游，旅于狄桑（Dim Sum）。 其邦小而俗尚侈，以鎦金云龍飾其城，而以玄玉覆于通衢。又製革囊數百，法日月星之形而以氣充之，上下懸浮，遍于都邑。其國中有圓几數張，白布覆之，男女老幼圍坐。貴人盛裝嚴飾，衣白裳黑，而以帛帶繫項。銀車駟馬，卷塵過市，民退避不及，輒斥之，其聲若鷗梟。有侍者導衛公及扈從坐，自午至申，方有貴婦人某氏于其車中取饌食而奉于公。有雉脯而浸之以赤油玄醬者，有附骨之肉而浸之以赤油玄醬者，有稻米之飴裹東海鮮蝦而浸之以赤油玄醬者，又用朱紅漂染于肉上，光鮮可喜。衛公醉飽辭歸，一男子逐于車後，舞蹈呼號。公意其為國主，故揖讓而亦蹈足以還禮。主人攝指成拳，揮舞于空中，衛公效仿之。主人遂護送公至一鏤金鑲銀之巨室，邀公沐洗杯盤十七日有奇，公大悅。

子曰："異哉斯國！為政者以能侍養百姓為貴焉。其有似于居豕犬之道乎？侍之不以為尊，食之不圖其報。不亦君子之政乎？能下小人，不亦君子之任乎？"

from the *analects* of confucius:

The Duke of Wei, in his travels to the South, came upon the city of Dim Sum. It was decorated with entwined golden dragons; its streets were marble, and all around floated globes filled with air. The town center was paved with circular tables cloaked in white cloth, around which the women, men, and children were seated. The nobles were dressed in identical costumes of white with a close-fitting over-robe of black, and a ribbon of black or white tied around their necks. They had silver carriages on wheels and shouted at the cowering populace in a dialect that sounded like birds of prey in the night. The Duke of Wei and his company were gestured to sit. After several hours, one of the noblewomen deigned to bring dishes from her carriage to his table. They were served chicken bathed in oil and dark soy; small pieces of pork attached to the bone and bathed in oil and dark soy; sea-sweet shrimp that had been wrapped in sheets fashioned from rice and bathed in oil and dark soy, and pork that had been dyed vermilion. When the Duke rose to leave, a man chased after him, stomping and howling. Presuming this to be their host, the Duke of Wei bowed and stomped his feet in return. The host clenched his fingers into a fist and waved it in the air. The Duke did the same. To the Duke's delight, the host escorted him into a large room that had been paneled with silver where the Duke of Wei washed dishes for seventeen and a half days.

Confucius comments, "What a strange land is this—in which those who rule look upon service as a mark of their station. It is not dissimilar in fact to the way we treat our own pigs and dogs! We feed them, expect nothing in return, and yet they are our inferiors. Is it also not the most noble way of government, for is it not the duty of those to serve the people who are beneath?"

《禮記》選段：

味精！其味甚甘！

一撑一掐，令汝如遭炎灼。

某日，吾飽食過甚，又飲酒爲歡。

忽于水邊顧影，而見一虎一僧。

from *the book of rites*:
MSG!
Tastes so sweet!
A pinch will make you parched.
Once, I ate too much.
I drank wine
Then looked in the lake and saw a tiger and a tonsured man.

《孟子》選段：

樂居（La Choy）城孤高峻朴，塔閣林立。其塔每層惟有一室，居一人而專一用。故侍女烹飪于庖廚，其上層為書房，主人治學其中，再上層則浴室，妃子沐浴焉。頂層便辟，為更衣之所，男子于左室寬衣，而著衣裳于右室；婦人亦然。入夜就寢，則雖夫婦亦以樓梯限隔。養兒之事尤繁複焉，為人母者，須炊而食其子于大兒進食之室，再乳其幼子于育嬰堂，然後登樓至小兒臥室，歌謠以送其入眠。

其燕居饗食皆在塔中，亦井然有秩，麥、醬、糜、蔬，五色斑斕而以籩豆分盛之。孟子游其國，乃依其所處之序分別食之。後兩日，主人告曰：宜將眾物混于一甌之中。因舉諸器皿，摻合佐料以示孟子，此先彼後，雜然無章。蓋序與不序，貴乎妙用也。每月亦有數夜，婦人入浴而其夫棄書往觀，為一夕歡樂。或招侍兒進酒食于浴室，或且廢而不食焉。其子亦入浴室道晚安，然後夫婦擁眠池中，至日曉雞鳴。故訪其國者，必先分食麥、醬、糜、蔬，而知其澀難下嚥。然後合諸物而饗之，則不獨識其味美，亦將有以識其國之禮俗矣。故其蔬雖湯灼失脆，其肉雖酥骨格槓，其醬雖烏光詭色，而知者將因其分之惡而盛稱其和之美也。蓋治味如治人，倘無界別，則亦何美之有？

from mencius:

The city of La Choy is tall and thin and austere. It is a city of towers, and within each tower, every story contains one room for one function and one person. Hence, the maid may cook in the kitchen, where above, her master works in his study, and above that, her mistress lingers in her bath. A man dresses in one room and undresses in another room on top; his wife does the same, and when they retire for the night, their sleep is separated by a staircase. A mother ascends to serve her child's meal in the child's place of dining, descends to the nursery to let her child suckle at her breast, then climbs to her child's bedroom to kiss the child goodnight.

The inhabitants' food is organized in towers as well, separate cylinders containing noodles, sauce, meat, and vegetables that are stacked high. On his visit to La Choy, Mencius ate his noodles, sauce, meat, and vegetables separately, in the order in which they were positioned. But after two days his host gestured that it was appropriate to combine the ingredients, and demonstrated by tipping the containers into one another in a haphazard order. For on rare nights in La Choy, a woman may be in her bath and her husband will ascend from his study to watch her bathe. The maid may serve them the meal in the bath, or they may eschew dinner altogether, and the child will enter to be kissed good night before man and wife drowse the night away on the warm bath tiles. When one comes to La Choy, one must eat the food separately at first, for one will find it difficult. To know that one can combine the components is a step toward understanding the city. Though the vegetables be parched, the meat full of gristle, and the sauce dark and curious, anyone who has known the taste of them apart will appreciate that the combined flavor is sweeter. For without boundaries, what beauty would there be?

《莊子》選段：

"芙蓉蛋"亦名"如餘蛋"，以制作繁奧，人不時見之。其色明燦如金絲雲雀，覆以鮮菌湯汁，又富含藥材,* 能使七賢人興舞快意，三日不止。

人告莊子曰："如餘蛋"乃"汝愚蛋"之訛，意為"汝何其愚也，是安有蛋！"蓋"如餘蛋"中絕無絲毫雞卵清黃，亦絕無鵝鴨雉龜之卵也。

莊子曰："善！汝愚蛋中無蛋，誠如鴨醬中無鴨。"

(*莊子乃論及雞精味素)

《樂府》選段：

雞卵流青黃，
漿果若丹朱。
鰻醃或窖釀，
製醬而待沽。
醬成曰"千島"，
盛名天下布。
散髮坐酒肆，
問君敢嘗否。
色香能斷魂，
使我意踟躕。

from zhuangzi:

Sometimes, one comes across the egg foo yong, a dish as bright as a canary, covered in mushroom soup, and containing enough medicine* to keep all Seven Sages elated for a week.

A friend told Zhuangzi that the full name of the dish was "Eggs? We fooled you!" For, as he explained, there are no eggs in egg foo yong, goose, duck, chicken, turtle, or otherwise. "How wonderful!" Zhuangzi responded. "For there are no eggs in egg foo yong, just as there is no duck in duck sauce."

(*Zhuangzi was referring to MSG.)

from *the book of songs*:

Sauce of thousand isles,
The venomous treat.
From the crimson fruit of nightshade,
And eggs that have never encountered heat.
Do I taste it?
Sitting in the wine shop with my hair in disarray.
The flavor of dying is discreet.

《馬可波羅遊記》選段：

旅程的最後一天，我應邀去參加大可汗的宴會，在那裡陳列着帝國中所有烹飪精華的象徵：La Choy塔，芙蓉蛋，雪花般的味精，還有鑲嵌着菠蘿的酸甜豬肉。有從全國各地精選出來的酒水調製的各種雞尾酒，其中一種酒色鮮紅而火焰升騰，他們稱之爲"熔岩之吻"，代表可汗陛下燒毀的那些他十分喜愛的城市中的一座。此外還有mai-tais、如翡翠般閃閃發亮的蚱蜢酒和漂浮着小陽傘的飲料，陽傘代表了某座城市中的婦女們，她們無時無刻不帶着傘，即便在室內也是如此，以保持膚色的絕對潔白。

"如果有一天我把這些美食的象徵嘗個遍"，可汗問我，"我是不是就能最終完全佔有我的帝國呢？"

我回答說："陛下，請別相信這種鬼話，真要有那麼一天，您大概會頭疼得要命。"

from *the travels of marco polo*:

And on that last day, I was asked to the banquet hall of the Great Khan, where were spread all the culinary emblems of the empire— towers of La Choy, egg foo yong, MSG gathered like snow, and sweet-and-sour pork studded with pineapple. There were cocktails made from liquors culled from all over the kingdom. There was one that was red and flamed and was called "Molten Kiss," to represent one of the Khan's favorite cities that had burned. There were mai tais and grasshoppers that glowed like jade and drinks with parasols to represent the women of one city that never went without them —even indoors—to keep their complexions white. "On the day when I have consumed all the emblems," the Khan asked me, "shall I be able to possess my empire, at last?" And I answered, "Sire, do not believe it. On that day you will have a hell of headache."

candy
coated
christine
d'onofrio

from the series *smarties* (2004)

more
ann shin

more

scrunching down on
nuts, fudge chocolate
quarter pounder
cheese thrusts grab
the torso, flick the pelvis
top it with a twinkie after
creamy macchiatos,
two sugar lumps for
cleavage where candyless
there was none.
what's missing
from this sour
pop rock bubblicious
life explosive
gulping eat-mores and
big macs holebound
never getting
enough landfill in my
sizewinding appetite
please

sugarstick this craving
with jelly donut holes
timbits of nothing.
compulsion is a scream
stopped up with a marshmallow.
aren't we rich enough,
educated and refined
enough, can't tell
this scrabbling head or
heart keeps seeking
gastronomic
plenitude.

catch of the day

Japan:
just before gutting it
your grandpa slaps the fish down
pressing paper to it, rubbing charcoal against
scales, an eye, the bones in each fin,
etching all of its fine, hair-like teeth.
the trout's image surfaces
like a daguerreotype
in his hands
ah kirei, kirei, he says, *ken oshi-so*[1]

Vancouver:
sprouting white fuzz
bricks of soybeans are laid out
fermenting, stinking up the streets for days.
grandma dumps an apronful into the sink
her hands sliding over the fuzzy blocks of mold
we eat that? I ask,
kuruchi, she slaps a brick,
ni jowa hanun daenjang ida[2]

Toronto:
your grandfather's etching now hangs on your wall
but your fish comes from Chinatown stalls
and I go to a Polish health food store
to buy Japanese miso

only an ocean and two generations ago
your grandfather saw it all in one fish, capturing it
twice, with a line he cast and a line he drew
linking sea to family, food to mouth, fish to eyes
to the wall where the etching hangs, the line
that connects us all.

[1] Japanese: Ah, beautiful, beautiful, and delicious.
[2] Korean: Of course, it's Korean miso, and you love it.

four levels of the present

trapped in the stop and go of Mumbai's Marine Drive
a woman taps an empty milk bottle against our taxi window
and holds her baby up, I look down at my sleeping daughter
her head sweaty on my lap tap tap red traffic light
the taxi inches forward to our right is the Chowpatty Beach Expo
hanging lights powered by young boys scampering like
hamsters in a wheel their thin wrists, brown fingers
tapping the bottle against our window, her baby's dry lips
the taxi inches red light my daughter turns in her sleep
two boys jump to the top of the Ferris wheel, hanging
from its rungs, their bony hips swinging as the wheel
falls forward to the screaming delight of
bottle tap tapping against the window, her eyes, stony, obdurate
the taxi inches forward the baby in the crook of her arm
parched lips my daughter's sweaty head
green light

lying on a mat on a rooftop in Goa
ocean waves tumbling and rushing below
as the wind in the palm trees rustles leaf against leaf
the cry of a baby through a window downstairs
insects ts-tsssing around your head
while past this rooftop on the beach below
waves crash into reef, sun warming your face
breeze brushing through the leafy palm trees
while downstairs a baby cries, you close your eyes
as insects lazily ts-tsss past your ear
in the distance the grand noise of waves rolling in
rustling palm fronds etched into the pale wind
the baby cries as the insects tss-circle
never landing on your skin, in the heat of the sun
the waves come tumbling in

from *factories of discontent*, a series

yes the conversation
was good wasn't good
calamities erupt in
minor strokes at brunch
leaving partial paralysis.
we make one last
extravagant attempt
to cure hands and toes verging
in perpetual intestinal gestures
between
my side and yours
are miles of antlers
and nimble conversation
laps it up so good we are
good-faced and busy
despite minor incontinences
doing fine thank you the bill
makes sense if not us.

if arms were wishbones I'd toss off
a dozen embraces for you, me and the rest of us
unloved, like masses lining up for a holy
division of knives and forks
could we find our feet again, somewhere
among the scattered silver.

house
beautiful
sian
bonnell

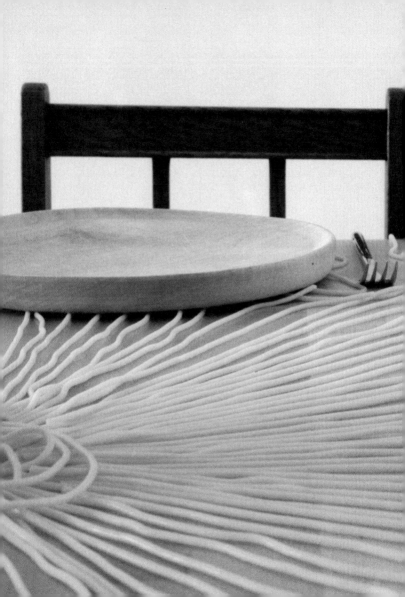

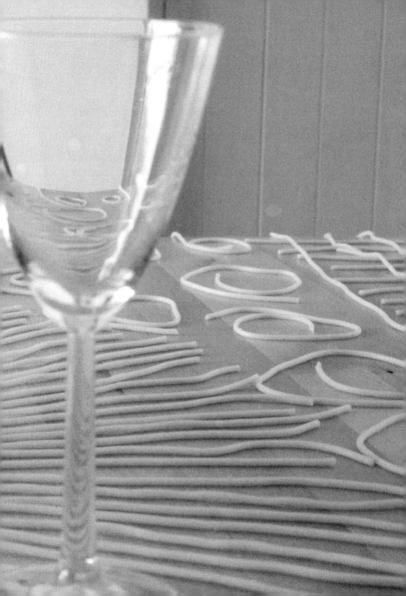

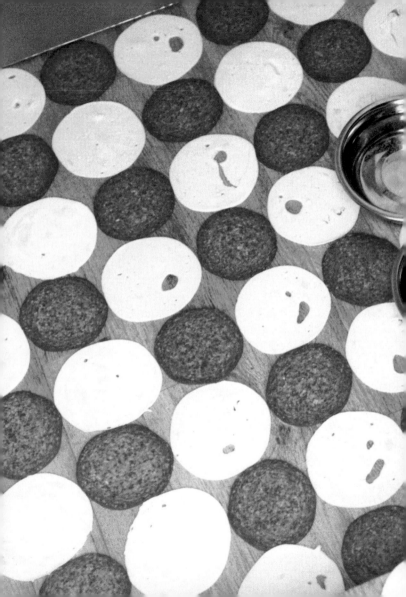

take back
the fruit:
public space
and
community
activism
fallen fruit

Fallen Fruit is an activist art project that started as a mapping of all the public fruit in our Los Angeles neighborhood, Silver Lake. We encourage everyone to harvest, map, plant, and sample public fruit, which is what we call all fruit on or overhanging public spaces such as sidewalks, streets, or parking lots. We believe fruit is a resource that should be commonly shared, like shells from the beach or mushrooms from the forest. We use these locational interventions to rethink public space, ecology, and ownership in urban neighborhoods.

Both the literal function of fruit and its figurative resonance are central to our project. Of all forms of food, fruit is the most symbolic; it is the food most often represented in art—perhaps because it is the most colorful—and it spans all cultures and historical periods. Fruit is universal and uniquely democratic, crossing all classes as a symbol of generosity and bounty. It is a healthy food, unrefined and requiring no processing; eaten virtually off the tree, it symbolizes the uncomplicated goodness of nature, beauty, fertility, and hospitality, not the excess or waste of commercial or industrial culture.

In its inception, the public fruit map simply described the things we saw: an urban neighborhood peppered with more or less neglected and unharvested peach, lemon, orange, kumquat, fig, loquat, avocado, and other trees. This is not so much a "new" resource as an invisible one, less a mapping than a remapping of what is already there. The public fruit map quickly moves from description to proposition: the city neighborhood can be seen both as a place where many people live and as a space that might support a far more significant amount of food production.

The public fruit map challenges our casual conceptions of urban sprawl displacing rural agriculture. It addresses what ecologists call the "carbon footprint" of the food we eat: the distance between food sources and consumers. Remapping according to public fruit is a way

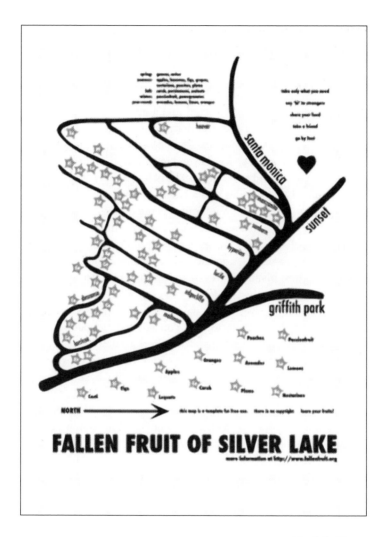

FALLEN FRUIT OF SILVER LAKE

more information at http://www.fallenfruit.org

to remake the city, to imagine it as a green place of sustainable agriculture or permaculture. The divorce of the agrarian from the urban is as old as the Industrial Revolution; the suburbs have been the one place in which fruits and vegetables re-emerge in the popular imagination—flight to the suburban homestead was motivated in part by the desire to have a piece of land and a garden. More and more modern cities follow the late-twentieth-century pattern of displacing the formerly green perimeters with unbounded sprawl, with little thought given to public spaces beyond malls and churches.

Every tree we find tells a story. The oldest remain from the time when much of Los Angeles was a citrus orchard, and many testify to the history of immigration: Latinos planted cactus, passion fruit vines and avocados; Asians the loquat and the kumquat, fruits still hard to find in local stores. We are especially fond of drought-tolerant tree crops, such as citrus, avocado, loquat, walnuts, and carob. As we advocate for new plantings, we stress their suitability to our climate. As we researched further, we found that each city has its emblematic fruit. The apricot thrives nearly wild in Santa Fe, New Mexico, and on almost every block in Los Angeles you will find a loquat tree. With a soft, fragile skin, a hard seed, and a flavor that combines an apricot with a mango, it is nearly unmarketable. It often occurs overhanging the street as what we call "drive-by fruit," pickable from the seat of a car—a commentary on the car culture of this city.

Urban fruit is blessed by neglect, almost always untended and thus organic; it is like the electric wires or the water systems underground, a layer of urban infrastructure that could be utilized far more than it is. Many people are uncertain about its basic edibility. They don't need to worry; it is entirely safe to eat. Even automobile soot simply wipes off. Its essentially organic status, never sprayed or fertilized, often barely watered, is striking to the health-conscious

consumer who usually pays dearly for the same thing at exclusive retailers like Whole Foods. In a mixed-class neighborhood like Silver Lake, this places the middle-class consumer in potential competition with the poor and the homeless. The question of public fruit goes to the heart of the relationship between those who have resources and those who do not. In a playful way it asks if these differences might entail any kind of obligation or hospitality.

Fallen Fruit regularly leads nocturnal fruit forages, which enable newcomers to see the neighborhood but also to see it differently. It's rare to walk in LA, much less after dark. Foraging at night heightens people's senses; most of us associate fruit with sunshine in the country, not urban darkness. We meet a lot of residents when we stop in front of their houses with flashlights, shopping carts, paper bags, and fruit pickers. It's an aspect of leading fruit tours at night we really value. Homeowners or residents are usually curious about us and we tell them what we are doing; invariably they tell us they have too much fruit to pick themselves or sometimes that they haven't ever picked it—the trees were just there when they moved in. Generally the exchange ends with an offer to let us pick more fruit inside their properties.

It's uncommon, at least in LA, to find people who actually use all the fruit growing on their property. The city has a policy of not planting fruit trees, though they will tend established fruit trees in public space (since their mandate is to keep the city as green as possible). The primary reason they cite, and not without justification, is the litter problem: fruits fall to the ground and end up feeding the city's unstoppable rodents. Thus the choice to plant a public fruit tree entails a commitment to its care and harvesting, so that the fruit will be an asset and not a liability to the neighborhood in which it grows.

We have come to see mapping as just the beginning, the opening into our project. The point of philosophy, said Karl Marx, is not just to understand the world, but to change it. By intervening in the geography of the space rather than describing it, you alter the texture of people's experience and hopefully their social relations. We encourage all who can to plant their property's perimeter with fruit trees to share. We're making plaques that announce this intention to passersby. Echoing the principles of public fruit, the plaques encourage pedestrians to sample but not hoard, to leave food for others and to explore the neighborhood on foot. They articulate a kind of gift economy: the residents are offering the public their fruit, some if not all of it, without expectation of any payment or return.

In the last two years we've submitted two fruit park proposals to the city and the parks department. A public park planted with only fruit-bearing trees echoes the tradition of the commons, property held in common for the benefit of all, such as pasture or woodlands. The fruit park would be designed in part to be educational, with informational displays on the various fruits and their role in the area's history. It would have a central gathering area in which fruit picked on the site could be cleaned, and excess home-grown fruit brought to the park could be left for others to share.

The public fruit park is not a new idea. For fifteen years, Earthworks, a community organization in Boston, has had a project called Urban Orchards, which plants and maintains fruit trees on recovered marginal land. The ethics of the fruit park is sharing, not hoarding. This kind of communalism and its basis in a gift economy is at odds with the capitalist system of exchange, since it asks for nothing in return. Conventional gift exchanges always imply a unspoken obligation, a kind of debt; it is expected that the recipient will eventually

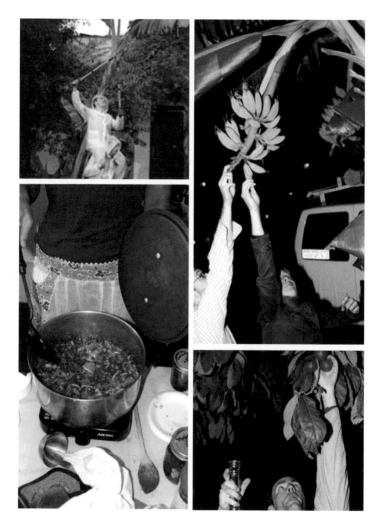

make a gift in return. It is perhaps not accidental that the fruit basket plays such a central, symbolic role in the giving of gifts.

Food, its preparation and sharing, is a cornerstone of culture. The domestication of fruit trees began at the point of human settlement (and the end of nomadism) and thus constitutes an early marker of civilization. Food is culture in the sense that it is at once an object, a crafted thing, and a symbol that, when exchanged, cements social relations. The public fruit park, with its gathering place and informational displays, is an embodiment of these communal precepts.

Another initiative of Fallen Fruit is the Public Fruit Jam, in which we invite the people of the city to join us in making jam. We've held these events mostly in art galleries. The jam is made from either public fruit or home-picked fruit that the participants bring along. Each batch is communal, created by at least five participants who negotiate the jam through basic recipes (which establish the ratio of pectin to fruit sugar), varying it with the selection of fruits, spices, and herbs that have been collected. Each jam is different, and each is collaborative. By this we intend to expand the event beyond the group of artists who established it to make it a truly public collaboration. The two art spaces with whom we have most often worked are Machine Project and LACE, Los Angeles Contemporary Exhibitions. Both are artist-run spaces and their programming favors alternative, political, and non-commercial work, in particular performance and installation.

The extra jars of jam are given away to visitors and participants. Because these events are mostly held in an art context, visitors often expect to pay for the jam, and are occasionally resistant when we explain that it is made from public fruit and intended to be given back to the public. But who is the public? This question is at the core of Fallen Fruit. One way we like to frame this question is to

suggest that the public is the nexus between those who have access to resources and those who do not.

While we have no great investment in Fallen Fruit as solely or even primarily an art project, that perspective offers us a set of categories that recast the overtly political nature of the project. Fruit allows us to create new psychogeographies of neighborhoods, new ways to see and experience social space. A vigorous new strain of art-making over the last decade has been described as relational aesthetics, art practices that focus less on the creation of tangible artifacts than on the relations among people those practices invoke. These new instances of social relations generate new forms of social thought as well as perhaps a new way of thinking about the role that art might serve in a world in which most art has again become a luxury commodity for the elite. All art must permit one to enter into a dialogue.

The conceptual artist Joseph Beuys described his work as "social sculpture," an interdisciplinary and participatory process in which language, ideas, and discussion are the primary "materials." All human beings are seen as artists responsible for the shaping of a democratic and sustainable social work of art known as the world. Similarly this pulls the aesthetic from its confines in the media of "art" and relocates it inside an imaginary collective workspace that allows us to envision and reshape the world to actualize our creative potential.

The "medium" of food can never be separated from the question of place. Perhaps more than a relational aesthetic, food offers us a way to interrogate place with what we call locational aesthetics, a way in which all locations can be discussed not just according to the edible cultural objects they do produce, but also those that they might produce. Curator and food writer Debra Solomon has coined

the term locative food to describe "food that tells me where I am and where it's from by its very name and nature . . . food that is not created by food product designers but by local people from local ingredients" (www.culiblog.org). In studying how the public in Europe and North America think of their food and the system by which it is delivered to them, one of the primary things researchers found is that food is personal: people connect it to eating and health, and they resist thinking of food as having systemic and political implications (www.sustainablefoodlab.org). The proposition behind Fallen Fruit is that new social formations can be created when we link the personal to the political by careful and playful attention to the local, to our own neighborhoods.

Debra Soloman (2005)
All I really want is locative food
www.culiblog.org

Sustainable Food Laboratory
Initiatives: Framing
www.sustainablefoodlab.org

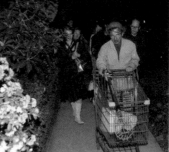

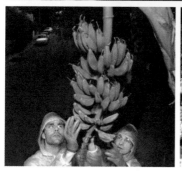

PUBLIC FRUIT JAM – EAT QU...

Only store this jam in a sealed ...
refrigerator. Or freeze for long...
public fruit and sugar with no ...

http://www.fallenfruit.org

attempt
at an
inventory
dean
baldwin

70

94

65

55

54

placing
food

nina-marie
lister

maps by jason globus-goldberg, adina israel, david carruthers
photographs by sophie bouy

Toronto is a fabulous city for eating. In this city-region of 5 million people there is no shortage of food choice, from *foie gras* to French fries. Comfort foods, exotic ingredients, and traditional fare of all of the city's myriad ethno-cultural groups abound in local shops and markets year-round. Lyrical menus cater to a global palate: phad thai, tikka masala, tostadas, dim sum, sushi, ceviche. Foods once considered luxuries or specialties are now staples, branded by every supermarket chain, while imported delicacies fill entire grocery aisles. And yet, amid these flavors of diversity, there is growing disparity, ambivalence, and ignorance. Indulgence and hunger coexist in this city of plenty, complicated by a lack of the most basic awareness of food as part of nature—of its sowing and growing, from seed to harvest; of time and place, seasons and soils. The elemental knowledge of what we eat is disappearing. In terms of food, everything from anywhere is available all the time for some, while basic subsistence remains out of reach for others. On the table, seasons no longer matter; nor does distance traveled, cost, or the farmer's name. Like other cosmopolitan urban regions, Toronto is a city with the menu of the world. So how is it that so much of this food diversity seems to come from nowhere in particular, while consumers—who are otherwise increasingly gastro-nomically knowledgeable—neither notice nor care? Have we become so disconnected from our food that we have forgotten the truth that underlies the cliché—*we are what we eat?*

The cornucopia that tempts Torontonians and other global urbanites is distracting us from the serious and growing problem of *placeless food.* If we look to the most common place of purchase as evidence, we find that for most supermarket shoppers the origin, growing, and production of food are invisible and irrelevant. In most cases, price is the deciding factor in what people will buy. Although interest in organic and more healthful foods is evident in the dedicated

organics sections that are now appearing even in the big supermarket chains, these comparatively expensive products are sold primarily to upscale consumers—and even these more discerning shoppers will often reject locally grown and seasonal produce in favor of something exotic from Mexico or South Africa that is certified "organic." But if we take seriously the intertwined issues of nutrition, health, local agriculture, food security for a growing population, and sustainability of the food supply, we ought to be very concerned with the place of food, and its place in our lives.

Sensitivity to place and seasonality is a subtle and elusive goal in the contemporary marketplace, with its overwhelming emphasis on diversity of selection and ever-increasing indulgence. In the Toronto region these powerful factors in consumption are brought together in synergy with southern Ontario's fertile farms, mass migration, and a booming economy. First, there is the land itself. On the glacial soils of the northwestern shore of Lake Ontario, Toronto enjoys a prime location in one of Canada's most arable regions. While just under 5 percent of Canada's vast 10-million-square-kilometer land base is classified as *prime agricultural land* (or Classes 1 to 3 according to the Canada Land Inventory), Ontario enjoys most of it: 51 percent, just over half of Canada's Class 1 farmland, is in Southern Ontario (Watkins et al. 6) and much of this area is within Toronto's "foodshed."

Like a watershed, which captures the rainfall in a particular land area and moves it through streams and underground channels into a local river or lake, a foodshed captures the food products that flow from local farms surrounding a given urban area, and routes them into the city to the population that will consume them. Based on the time it would take an urbanite to make a short day trip to a local farm to pick apples or buy fresh corn, or for a local farmer to bring her produce to a Saturday market, Toronto's foodshed reasonably lies

●	= 100 vegetable crops
●	= 100 fruit crops
●	= 1000 cattle
■	= City of Toronto

Toronto's foodshed

Produce crops and cattle within a 200km radius.
Data: Ontario Ministry of Agriculture, Food, and Rural Affairs, 2005

within a two-hundred-kilometer radius of the city. To the south and west of Toronto lies the most productive part of our foodshed: the mixed-agricultural areas of Wellington and Haldimand-Norfolk counties, the corn and soybean fields of Oxford, and the tender-fruit lands of Niagara where grapes and stone fruits—cherries, peaches, plums, pears and apricots—abound. To the north of Toronto lies the bulk of the Greenbelt, a new 720,000-hectare (1.8 million acres) strip of land that has been designated off limits to urban development, to protect natural areas and encourage working farmland; farther north, beyond this belt, are the beef and hog farms of the Simcoe-Grey region. To the east of Toronto there remains a patchwork quilt of small family-run farms in Oshawa, Cobourg, Peterborough, the Kawarthas, and Prince Edward County.

Despite the extremes of the continental climate, an incredible variety of food is grown in Southern Ontario. The growing season is short but intense, from late May to mid-October, and the long hot days in mid-summer are ideal for ripening summer produce and setting winter vegetables. Early settlers quickly learned the rhythms of the seasons. They planted and harvested their crops in waves washed in by the summer sun: first the tender spring greens and early-ripening vegetables, from asparagus to peas; then the longer-ripening, bigger produce, such as beans, corn, tomatoes, and stone fruits; ending in autumn with frost-hardy, long-lasting apples and the dense vegetables of winter, from pumpkins and squash to kale and collards.

For many generations, Canadians took advantage of the bountiful fall harvest and made it last all winter, through preserving, pickling, and canning, arts well known to our grandparents though all but lost today. Now the long winters and relatively short growing seasons are irrelevant, and even hemispheres don't matter. No longer do Canadians look forward to June and the sweetness of the tiny perfect

fruit that once signaled summer—the strawberry, one of only a few fruits native to Canada, has become a staple. Thanks to a synergy of consumer demand, the Green Revolution of fertilizers and pesticides, comparatively low-cost fuel, falling commodity prices, and ease of transportation, consumers can have whatever they want whenever they want it.

Who are they, the people of Toronto, who consume all this food? As Canada's largest city, Toronto is the fifth-largest urban center in North America, after Mexico City, New York, Los Angeles and Chicago (City Mayors' Statistics). It is also one of the fastest-growing city-regions in Canada, growing in cultural diversity as well as size (Ontario Ministry of Public Infrastructure Renewal 12; Statistics Canada 2006, 9–10). Once known as a British colonial outpost, where shops closed on Sunday and coffee was an exotic drink, Toronto now has more Muslim than Presbyterian residents (Troper 4). Notably, the city is home to 43 percent (792,000) of all new immigrants to Canada (McIsaac 9), and there is a higher proportion of immigrants in Toronto's population than in many other global urban centers: almost half (47 percent) of Toronto's residents were born in another country compared with 40 percent in Miami, 31 percent in Sydney, 30 percent in Los Angeles, and 23 percent in New York City (Hou and Bourne 9; McIsaac 59). Torontonians come from more than two hundred countries of origin and speak more than one hundred different languages; more than a third of the city's residents speak a language other than English at home and 43 percent are members of a visible minority (Statistics Canada 2001).

The changes in Toronto's population—and in its collective pantry—began in earnest after the Second World War. Today, both the pace of immigration and the diversity of newcomers' countries of origin have increased significantly. Of the more than 125,000

Toronto's ethnic diversity

The map is based on an index which measures the extent to which members of different ethnicities are "mixed" in a given dissemination area. The number of ethnicities, as well as the number of people belonging to each ethnicity, is taken into account in the creation of the index.

Data: City of Toronto

immigrants arriving in Ontario each year, almost half come from five countries: India, China, Pakistan, the Philippines, and Iran—and most settle in Toronto (Dowding-Paré). Immigration from non-European countries has transformed Toronto, stocking grocery stores with the foods of the world. The city has an almost unimaginable variety of places to eat and shops in which to buy food: 6,172 food service establishments (of which 4,675 are restaurants) and 4,884 food shops and grocery stores (Food and Hunger Action Committee 2001a, 22; Center for the Study of Commercial Activity). Toronto's Ontario Food Terminal, with its vibrant Saturday farmers' market, is the largest wholesale produce distribution center in Canada and ranks in the top five such centers in North America (Ontario Food Terminal Board); it supplies the city's myriad greengrocers, which far outnumber those in the average US city (Cosgrove 23). Furthermore, many of these groceries, restaurants and food retailers are ethno-specific, from Chinese groceries and Greek bakers to Indian buffets and Portuguese fishmongers. There is nothing you can't get in Toronto. All year round, grocery shelves are stocked with the same array of foods—only the geography changes with the seasons: mussels from Prince Edward Island one month and New Zealand the next; in summer, apples from South Africa; winter asparagus from Peru; spring corn from Texas; winter grapes from Chile.

Today's consumers want cheap food, fast. They want a lot of it, and they want it 24/7. They don't care where it comes from. But ultimately, the feast may come at a much higher price than we imagine. The real costs of ubiquitously available food, coupled with a cultural ambivalence towards—and growing ignorance of—its production and place of origin, may be invisible to most of us now, but as a society we will pay eventually. As Barbara Kingsolver warns, "we get [cheap food] at a price…not measured in money, but in untallied debts that

will be paid by our children in the currency of extinctions, economic unravelings, and global climate change" (4).

the perils of placeless food

The risks of placeless food—food that comes from anywhere and everywhere—are worth considering. One of the most immediate concerns is that in spite of access to everything, many city residents have nothing to eat. Hunger is a growing problem in this city of plenty, which somehow has more food banks than McDonald's outlets (Toronto Food Policy Council 1994, 6). The reasons for urban poverty and hunger are complex, but they are deeply rooted in our attitudes to food and the way in which we grow, market, import, and sell it. When the food supply is ruled by the laws of commerce rather than respectful of the laws of nature, and food retailers cater ever more exclusively to the affluent, the result further marginalizes the poor. People who in the past could at least grow vegetables in the summer are now more often dependent on food banks to feed their children and themselves.

Environmental risks are significant, as food sources become industrialized, centralized, and mass-produced. In particular, the loss of genetic diversity and eventual extinction in seeds and crop stock are paramount concerns to global food security. Other related threats to environmental health result from agricultural pollution, declining soil fertility, and the loss of habitat for other species that co-exist on farmland. Increased reliance on fertilizers, pesticides, fossil fuels used in farming, and widespread irrigation at once impoverish and contaminate the biosphere.

There are other societal and economic risks, too, including loss of farming as a basic skill, the disappearance of the rural community

and way of life, and the decline of the local agricultural economy. For the population as a whole placeless food may pose long-term health risks, some of them poorly understood, as foods travel farther to market, losing vital nutrients in transit, and as foods are mass-produced, genetically engineered, and grown with an increasing reliance on chemical pesticides and fertilizers.

At the root of these complex risks is a relatively simple question of value. If a society does not value its farmers and farmland, then it does not value the capacity to grow its own food, and both will eventually be lost. For small farmers in particular, farming is becoming an unsustainable activity, and for those who are close to an encroaching city, it is often more profitable to sell their land than to farm it (Watkins et al. 7). Each rural severance further fragments the landscape. Fields and orchards are quickly converted into rural residential communities, then suburbs, and eventually more homogeneous suburban sprawl. Ontario has no specific legislation to protect farmland, and as long as land prices continue to rise in the urban fringe, farmers are selling out and moving on. And who can blame them, when it costs more to sow and tend a crop than they can make selling it? Bunce and Maurer report that it costs $1.40 (per pound) to raise a hog for market, yet Ontario's major meat processor, Maple Leaf Foods, will pay only $1.35 for the same hog (27). In this way, corporate food processing monopolies force tight margins on farmers, resulting in a significant economic challenge for many who already supplement their farm income, with up to two-thirds of their household income derived from non-farm activities. Overall, rising costs and declining commodity prices are seen as major barriers to the viability of local farming in the long term (Bunce and Maurer 26).

Couple this trend with accelerating population growth in Toronto, and local farmland is truly at risk. As the third-fastest-growing

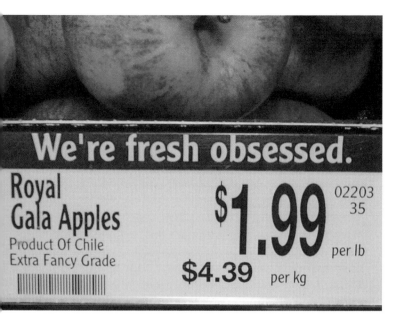

All year round, grocery shelves are stocked with the same array of foods— only the geography changes with the seasons: mussels from Prince Edward Island one month and New Zealand the next; in summer, apples from South Africa; winter asparagus from Peru; spring corn from Texas.

metropolitan area in North America, the Greater Toronto Area (GTA) had a population of 5.8 million in 2005 and is projected to reach 8.6 million by 2031 (Ontario Ministry of Public Infrastructure Renewal: Schedule 3). Land in the urban fringe will be needed to house this growing population, and a good deal of it is dependable farmland. Furthermore, much of the agriculture in the outer city limits takes place on rented land (Bunce and Maurer 34), which has already been sold on speculation to developers, and is rented back by farmers. Between 1951 and 2001, the already limited supply of Canada's quality agricultural land declined by 4 percent, while the demand for cultivated land increased by 20 percent.

By 2001, about half of Canada's total urbanized area was located on what was once quality agricultural land, and is now irrevocably lost. In Ontario the situation is grim: more than half of all Canada's prime agricultural land (56 percent) is in Ontario, most of it concentrated in the heavily urbanized areas of the south, in Toronto's urban shadow (Hofmann et al. 7–8). Indeed, most of Ontario's quality farmland is visible from the top of Toronto's CN Tower. If this trend continues unchecked, another 40 percent of the prime land that is still productive today will be lost by 2026 (Cosgrove 8). At that point, Toronto will no longer be "food secure"; *the city will be unable to feed itself.* Given these figures it is hard to take seriously the current political drive to make Toronto North America's "greenest," most sustainable city (Gorrie).

Some critics argue that the city is already food insecure, as Toronto has become increasingly reliant on food imports. According to the Food and Hunger Action Committee (FHAC), in 1960 most of Toronto's food came from within 350 kilometers of the city, or almost entirely from within its foodshed (FHAC 2001b, 3). Today the city's food comes from virtually everywhere: the average North American

food molecule travels 3,000 kilometers, with between 10 and 15 calories of energy required to deliver 1 calorie of food (Cosgrove 28). At least 60 percent of the fresh produce consumed in Toronto is imported from the United States, and a third of this arrives during Ontario's own growing season, competing with local produce for a place in the grocery basket. About $172 million is spent annually in the GTA to import fresh vegetables, many of which can be grown here (FHAC 2001a, 13). Put another way, despite having more than half of Canada's most productive agricultural land, Ontario has a food deficit of approximately $3 billion (Cosgrove 21).

We are also allowing ever larger corporate bodies to control the production and consumption of food. "Supersizing" is changing everything from big-box retail outlets and supermarkets to portion sizes and farms. Small family farms have shrunk in both size and number, while large-scale agricultural industries have grown. The number of farms in Canada has dropped from 711,000 in 1921 to fewer than 250,000 today, while the average farm grew from 237 acres to 675 acres between 1941 and 2001 (Heintzman 2). The combined forces of urban pressure on farmland, low prices from corporate food processors, and increasing reliance on food imports (many of which can be produced more inexpensively elsewhere) make for a grim economic outlook for the local family farm. In a recent study by Bunce and Maurer (25) many Toronto-area farmers expressed pessimism about the future of farming, describing their situation as "desperate," "bleak," "terrible," "tough," and "precarious." Most of these farmers do not see a future in farming for their children and, in fact, would not encourage them to stay on the farm.

The massive single-crop agribusinesses that have replaced the family farm tend to use more aggressive agricultural practices, including more intensive irrigation, fertilizers, herbicides, and

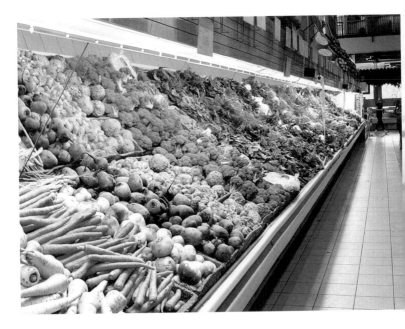

In 1960 most of Toronto's food came from within 350 kilometers of the city, or almost entirely from within its foodshed. Today, at least 60 percent of the fresh produce consumed in Toronto is imported from the United States, a third of this arrives during Ontario's own growing season.

pesticides. Farms in Canada and throughout the industrialized countries have evolved into major business concerns, mass-producing pork rather than pigs, or operating beef feedlots rather than cattle farms. Some argue that this transformation from agriculture into industry is an assault on local ecosystems and poor farmers alike, homogenizing and reducing the natural diversity of seeds, habitats, and landscapes (Shiva 122).

To achieve economies of scale and predictable profits, industrial agriculture imposes uniform crop types and management practices, such as standardized planting and harvesting dates. As a result, biological and genetic diversity has declined on most farms in Canada and other industrialized countries over the last century, and virtually all modernized farms are now monocultures. Low crop diversity in turn results in reduced diversity of other species, such as insects, birds, and soil organisms. Furthermore, monocultures increase dependence on pesticides, because pests and disease can infest and infect monocultures more readily than diverse crop mixtures. Not surprisingly, monocultures also have lower populations of natural enemies that prey on pests, such as spiders, wasps, dragonflies, and predatory beetles (Picone and Van Tassel 100).

Today just three high-yielding varieties of rice, wheat, and corn provide 60 percent of the human diet worldwide. According to the Food and Agriculture Organization (FAO) of the United Nations, 75 percent of crop diversity was lost during the twentieth century as traditional crops were edged out, while modern cultivars have replaced older varieties for 70 percent of the world's corn, 75 percent of Asian rice, and half of the wheat in Africa, Latin America, and Asia. In 1950, India had more than 30,000 wild varieties of rice, but only 50 are expected to remain by 2015 (Picone and Van Tassel 100). Of 7,098 apple varieties cultivated between 1804 and 1904,

approximately 86 percent have been lost. Similarly, 95 percent of cabbages, 94 percent of peas, 91 percent of field corns, and 81 percent of tomato varieties no longer exist (FAO 1998, 14). Native to the Andes region of Peru, the humble potato has more than 5,000 native cultivars; in North America, a *single* variety, the russet, now accounts for nearly 75 percent of planted acreage. Almost the entire crop is used by the food service sector to produce frozen French fries (United States Department of Agriculture). In losing traditional plant varieties, we also lose forever the unique genetic history of each species and, along with it, genes for disease and pest resistance, as well as the potential for adaptation to differences in soils and climate. In effect, as we simplify our food system, we are attacking the environment's capacity for future evolution and adaptation to inevitable change.

Although industrial agriculture has increased global food production to record levels, it has done so through reliance on chemicals that were originally designed for warfare. Pesticides were developed from nerve agents, herbicides from defoliants. One of the world's largest agricultural biotechnology companies, Monsanto, manufactured Agent Orange and DDT, two of the most notorious chemicals associated with the Vietnam War and the Green Revolution respectively, while today the company produces both genetically engineered seeds and the pesticides and herbicides on which they are programmed to depend. The names of the pesticides manufactured by Monsanto and its affiliates evoke this warlike approach: "Lasso," "Machete," "Roundup," "Prowl," and "Avenge." As Vandana Shiva observes, "this is the language of war, not sustainability" (123).

The recent patent of "terminator technology" extends the disturbing association of food and war. In this new process plants are genetically engineered to produce "sterile seeds"—a particularly sinister oxymoron. Critics charge that the technology is nothing

short of a threat to human survival, an insidious assault on both farmers and ecosystems, creating a culture of economic dependence in farmers who use the seed, and an unknown risk of genetic contamination in wild seed and other cultivated crops. Most farmers worldwide, and many small local farmers, still collect their best seeds from each year's harvest to replant the following year. In doing so, they are selecting the fittest crop for their own soil, climate, and growing conditions, and ensuring the genetic health of their crops over time. By gathering and saving seeds—the kernel in which life itself is contained—farmers are also ensuring that the essence of place is embedded within each crop produced, reflecting within each plant the specific conditions to which it is uniquely adapted. The notion of plants that cannot reproduce themselves is as repugnant as it is dangerous, threatening the long-term sustainability of the food supply and the adaptive resilience of global ecosystems.

Yet the business of agriculture is now firmly entrenched in a general trend toward globalization and corporatization. Today, more food is produced per person than at any other time on earth (Picone and Van Tassel 99) and farming at any scale is now inextricably tied to corporate consolidation of the food system. In Toronto, 50 percent of all foods flow through three corporate providers: half of Toronto's supermarkets are owned by Loblaws (Weston), A&P (Metro), and Sobeys (Empire). As a result, we have the most oligopolistic food economy in the Western world in which a small group of powerful players effectively controls our food supply (TFPC 1994, 37; 1996, 6). Some analysts have found that such corporate consolidation contributes to higher food retail prices than would be otherwise set in a more diverse food economy (TFPC 1994, 12). The small farmer, the market gardener, and the local organic growers don't stand a chance in this system, where they cannot compete on price.

= food desert
= restaurant & grocery catchment areas

Toronto's food deserts

Food deserts are large gaps in the city where it is difficult or impossible to find a grocery store or supermarket within walking distance, and where the predominant means to buy food is through fast-food outlets and higher-priced convenience stores.

Nor does the low-income consumer see any benefit: food prices in their neighborhoods are often the same as or higher than in more affluent parts of the city. When prices were averaged across Toronto, the poorest neighborhoods were second only to the wealthiest: Toronto's downtown low-income neighborhood of Regent–Moss Park had the second most expensive convenience stores, after the wealthiest area of Davisville. Notably, high-priced convenience stores dominate the food supply in Regent–Moss Park, comprising 62 percent of all food retail, while lower-priced grocers supplying more nutritious food choices represent only 2 percent of neighborhood food retail (TFPC 1996, 9). While Toronto has a wide variety of food choices, there are large gaps in the urban fabric where basic access to high-quality food is a problem. In these "food deserts" within the city—areas where it is difficult or impossible to find a grocery store or supermarket within walking distance, and where the predominant means to buy food is through fast-food outlets and higher-priced convenience stores—food prices are inversely proportional to nutritional value.

Poverty, malnutrition, and hunger are serious social harms, particularly among children, immigrants, and seniors. As in many large cities, some of the poorest areas of Toronto are also those of the highest ethno-cultural diversity, populated by newcomers struggling financially, emotionally, or culturally. Adding to their difficulties is the fact that good-quality food can be unaffordable and inaccessible in their neighborhoods. Toronto's aging population is significantly at risk too: 50 percent of Toronto residents over the age of fifty-five are considered nutritionally vulnerable, leading to reduced health outcomes (Cosgrove 27). The lack of affordable housing in Toronto (for these groups in particular, but for the average resident as well) is directly responsible for hunger: food bank users in the GTA are

paying an average of 73 percent or more of their income on rent, leaving less than $5 a day for food. For context, social services agencies consider that 30 percent of income spent on shelter is "affordable," and 50 percent is considered to put a person at an extreme risk of homelessness (DBFB 14). Roughly 20 percent of Toronto residents do not have sufficient income to meet their basic expenses, and thus cannot afford a healthy diet (Cosgrove 14). The hunger crisis is compounded by a growing disparity between income groups. The median family income in the poorest 10 percent of neighborhoods of Toronto has risen only 0.2 percent since 1980, whereas in the richest 10 percent of neighborhoods, it was up 23.3 percent (Heisz 18). Toronto's neighborhoods reflect this increasingly sharp division, with the country's lowest-income neighborhoods clustered around an affluent core, home to the country's wealthiest residents.

Not surprisingly, food bank use in the city has become widespread, and is increasing. The city has 106 food banks and 36 smaller food pantries (FHAC 2001a, 8), all of which are used regularly. At one time, food banks held only seasonal food drives and food bank users were a relatively small group of the decidedly poor. Today, food bank users come from a wider cross-section of the population, including a large portion of the lower middle class and about 24 percent who are classed as the "working poor"—minimum-wage earners who, despite holding regular employment, cannot afford basic necessities (DBFB 16). In 2000 a comprehensive survey of all hunger-relief and emergency food programs in Toronto found that 60,000 people use food banks each month, with 50 percent of these users having no money for food at least once a week (FHAC 2000, 9–10). Today, 75,500 people use food banks each month in the GTA: of these users 48 percent are new immigrants and 38 percent are children, 20 percent of whom go hungry at least once a week, which represents a 100

Total number of people reliant on food banks within the GTA

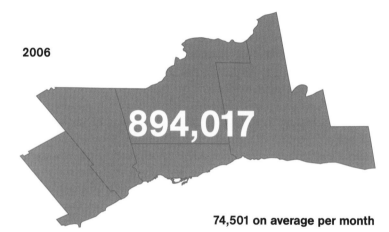

2006

894,017

74,501 on average per month

The people who use the GTA's neighborhood food banks

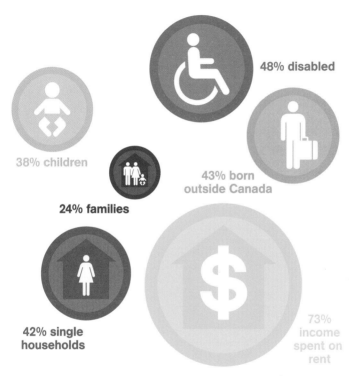

48% disabled

38% children

24% families

43% born outside Canada

42% single households

73% income spent on rent

median income/month $954

Source: Adapted from Daily Bread Food Bank, 2006

percent increase in the past decade (DBFB 8). Increasingly, seniors are turning to food banks for help as well: 11 percent of food bank users were over sixty in 2000, compared to 6 percent in 1995 (FHAC 2000, 6). Overall, food bank use is up by 79 percent since 1995. With 1.2 million emergency meals served every month in Toronto (FHAC 2001a, 28), food security is a major issue on the urban agenda.

activating the edible landscape

What can Toronto do to ensure the long-term sustainability of a safe, healthy, and accessible food supply? This is a significant challenge faced by cities all over the urbanizing world: too much reliance on food from "elsewhere" unbalances our food systems; provenance is lost, along with the ability to adapt to changes in climate or fuel prices, or to accommodate outbreaks of pests or disease. The ecological systems on which humans ultimately depend for clean air, water, and food are examples of resilient, flexible, and highly adaptive systems operating on many levels, in multiple contexts and with a lot of redundancy: they are not confined to monocultures, agricultural or otherwise. Above all, ecological systems are evolved from context and place: they are specific to the uniqueness and nuance of the landscapes in which they function. This is the critical link to be restored in urban food systems—a necessary rebalancing of food from global to local.

This is not a naïve suggestion for a return to pastoral life, but rather a recognition of how resilient systems operate. Food systems must operate at multiple scales—both global and local—using many approaches. The renewal of a robust food system will involve both small- and large-scale changes in the way our cities work. One tangible step forward would be to re-establish and reaffirm the place

of food in local landscapes. There are many ways in which cities like Toronto can activate an edible landscape, in which locally grown food is a valued and accessible resource.

Toronto's newly declared greenbelt is a working foodshed, with over 7,000 farms producing fruit, vegetables, pork, beef, lamb, mushrooms, maple syrup, tender fruits, stone fruits, and wines (see: www.ourgreenbelt.ca). These lands are legally protected from urban development for the purposes of both natural heritage and agricultural conservation. Although not without controversy, metropolitan greenbelts here and in Melbourne, Canberra, Dunedin (NZ), Vancouver, and Ottawa (as well as some US urban growth boundaries) serve an important function in keeping land under cultivation in the creeping urban shadow. But to be effective, these lands must encompass dependable, high-quality farmland, not merely undevelopable land that happens to be available. Cities like Toronto need to consider seriously a concomitant approach to greenbelts for near-urban agricultural planning that includes, for example, farmland trusts, agricultural preserves, and—most important—tax incentives to keep farmers on the land and the land working. Greenbelts are a step in the right direction but alone they are not enough to restore the right of farmers and food producers to make a living in the urban fringe.

To challenge the superstores and mega-marts that dominate the consumer landscape, distribution strategies are also needed to bring food to the urban market, and the urban market to the farm. The Farm Fresh Locator, an interactive web-based map of Toronto's foodshed, is a simple, informative directory that allows car-equipped urbanites to find and shop at local farms themselves. Organizations like Local Flavour Plus work to foster local sustainable food systems by certifying farmers and processors and linking them with local retail purchasers. Within the city, farmers' markets are a more

traditional venue for local food: they can be informal or large-scale establishments in covered marketplaces, but they need urban planning policies and community appeal to entrench them in the fabric of the city. Community food organizations need to work closely with municipal agencies to secure urban sites for markets and nurseries and to promote the value of local produce. For example, Chicago's Growing Power runs demonstration/training gardens in Milwaukee and a kitchen potager garden in Chicago's Grant Park. In Toronto, the Evergreen Foundation has similar plans to re-use a historic postindustrial brick-making site for a native plant nursery, a farmers' market and an organic kitchen in the heart of the city. These and other community- and city-supported farmers' markets also provide an opportunity to sell produce at deep discounts, increasing access to affordable food (FHAC 2003, 14).

The direct purchase of farm goods can be organized in many ways. To help city residents connect with local farmers, community shared agriculture (CSA) projects are an innovation that works well. Each year in early spring, customers purchase a subscription or one share of the year's harvest (often organically grown) from a local farm—whether rural or urban agriculture. By paying for their produce in advance, at the beginning of the growing season, CSA shareholders provide the start-up capital necessary for farmers to purchase the year's seeds and supplies, thereby eliminating the farmer's dependence on bank loans and chemical inputs to guarantee the harvest (e.g., Toronto's Foodshare is an urban CSA while Vicki's Veggies is a local rural CSA). CSA farms are growing in both number and popularity, with now approximately a thousand CSA farms in North America (University of Massachusetts Amherst).

Country villages and regions with gastronomic specialties are now tourist destinations, marketed to urbanites as part of rural

95 percent of cabbages, 94 percent of peas, 91 percent of field corns, and 81 percent of tomato varieties no longer exist. As we simplify our food system, we are attacking the environment's capacity for evolution and adaptation to inevitable change.

economic development strategies. Within two hundred kilometers in either direction of Toronto there are "wine routes" and "taste trails" from Niagara to Prince Edward County, each offering a mapped route of rural agricultural discovery, with accommodation, dining, and plentiful opportunities to purchase food products directly from farm stands and town markets. This kind of niche marketing helps the producers, but doesn't reach the population who are in greatest need of healthy, affordable food. Strategies that address food security directly are most needed.

Food security is statistically and culturally difficult to measure, but is of growing importance in urban public policy worldwide: it exists when all people in a given place, at all times, have access to sufficient, safe, and nutritious food to meet their dietary needs for an active and healthy life (FAO 2002). People must have such access consistently and reliably, without resorting to emergency supplies, scavenging, stealing, or other coping strategies (Committee on National Statistics 22). Experts agree that food security is a complex problem in most large cities: an affordable and consistent supply of high-quality food cannot be guaranteed to all residents without some combination of social policy, market incentives, and tools for self-reliance. Food banks should not be allowed to become a permanent, internalized feature of the food system; other strategies can be adopted. For example, subsidies for fresh food box delivery, food recycling programs from restaurants to community kitchens, urban agricultural cooperatives, community gardens, and planning policies that designate specific grocery retail locations can all make important contributions.

Urban agriculture is a significant component in fostering self-reliance for food security and in activating an edible landscape. Broadly defined, it includes any farming activity—for personal

or family use, or for profit—within or close to city limits. Rooftop gardening, container gardening, commercial greenhouses, and community gardens are all strategies of urban agriculture that can be practiced intensively in small private gardens or community plots, or extensively in commercial production in parks, greenfields or on vacant land. For example, the Toronto Community Gardening Network estimates Toronto has roughly four thousand acres of idle land that could be used for community urban agriculture (Roberts 10). The first community garden was established in Toronto in High Park in 1973, and there are now more than a hundred community gardens in the city, with 3,000 plots being used by 4,500 residents to grow fresh fruits and vegetables, each plot producing between $200 and $300 worth of fresh food annually (FHAC 2000, 25; 2001a, 32).

The Toronto Food Policy Council estimates that it would be possible to grow 16,700 tonnes, or about 10 percent of the city's vegetables, within or very close to the city limits. Some of these crops could be grown in greenhouses creatively (and potentially temporarily) constructed on brownfields—vacant lands that would be otherwise unusable for food production due to contamination (FHAC 2001a, 42–43). The mosaic of urban agriculture includes many other initiatives, such as place-specific specialty gardens. There are native plant nurseries in Sydney and San Francisco and children's gardens in Toronto and Melbourne. Toronto now has five children's gardens for teaching and hands-on learning about gardening and nutrition (FHAC 2003, 9, 32).

While most community gardeners grow food for themselves, some donate all or a portion of their produce to food banks, while others grow produce to sell, particularly to restaurants seeking specialty produce such as Asian greens and herbs. There is a large

One tangible step forward would be to re-establish and reaffirm the place of food in local landscapes. There are many ways in which cities like Toronto can activate an edible landscape, in which locally grown food is a valued and accessible resource.

and growing market for ethno-culturally specific crops among restaurateurs and markets (FHAC 2003, 9, 27). While some are field crops that can be grown locally in both urban and rural areas, others are subtropical or tropical and can be cultivated in greenhouses within city limits. Small-scale local farmers are remarkably adept at seizing new market niches, and have experimented with a variety of crops over time (Bunce and Maurer 39). But they need to be connected to new networks and opportunities, such as those offered by a major city's multicultural consumer base.

Toronto *can* guarantee its own food security. Most cities are located on or near dependable farmland for the simple reason that people settled where they could reliably produce good food. Toronto is no different. Through a synergy of innovative policies, bold legislation, and creative community action, Toronto can reassert itself at the center of a plentiful foodshed and a robust food system. Redesigning an edible landscape is an important step in a long-term strategy, reconnecting food to place, and place to food. In committing ourselves to this basic act of recovery, we can regain our ability to feed ourselves and in so doing, honor the land that ultimately sustains us.

Michael Bunce and
Jeanne Maurer (2005)
*Prospects for Agriculture in the Toronto
Region: The Farmer Perspective*
Toronto: Neptis Foundation

Centre for the Study of Commercial
Activity (2005)
CSCA data, 2005
Toronto: Centre for the
Study of Commercial Activity,
Ryerson University

City Mayors' Statistics (2006)
World's Largest Urban Areas 2006
www.citymayors.com

Committee on National
Statistics (2005)
*Measuring Food Insecurity and Hunger:
Phase 1 Report*
Report of the Panel to Review US
Department of Agriculture's
Measurement of Food Insecurity and
Hunger, Committee on National
Statistics, National Research Councils
of the National Academies
Washington: National Academies Press

Sean Cosgrove (2000)
*Food Secure City: Toronto Food Policy
Council Submission to the Toronto
Official Plan*
Toronto: City of Toronto, Toronto Food
Policy Council

Daily Bread Food Bank (2006)
*Who's Hungry? The 2006 Profile
of Hunger in the GTA*
Toronto: Daily Bread Food Bank

Mary Dowding-Paré (2005)
Ontario Immigration Facts Sheet
www.citizenship.gov.on.ca

Food and Agriculture
Organization (1998)
*Report on the State of the World's
Plant Genetic Resources for Food
and Agriculture*
Rome: United Nations, Food and
Agriculture Organization

Food and Agriculture
Organization (2002)
*The State of Food Insecurity in the
World 2001*
Rome: United Nations, Food and
Agriculture Organization

Food and Hunger Action
Committee (2000)
Planting the Seeds: Phase 1 Report
Toronto: City of Toronto, Food and
Hunger Action Committee

Food and Hunger Action
Committee (2001a)
The Growing Season: Phase 2 Report
Toronto: City of Toronto

Food and Hunger Action
Committee (2001b)
Toronto's Food Charter: Towards a
Food-Secure City
Toronto: City of Toronto

Food and Hunger Action
Committee (2003)
Tending the Garden: Final Report
Toronto: City of Toronto

Peter Gorrie (2007)
Toronto's Green Blueprint
Toronto Star February 17

Andrew Heintzman (2006)
The Real Cost of Food
enRoute Magazine November

Andrew Heisz (2005)
*Ten Things to Know About Canadian
Metropolitan Areas: A Synthesis of
Statistics Canada's Trends and
Conditions in Census Metropolitan
Areas Series.*
Ottawa: Ministry of Industry

Nancy Hofmann, Giuseppe Filoso, and
Mike Schofield (2005)
The Loss of Dependable Agricultural
Land in Canada
*Rural and Small Town Canada Analysis
Bulletin* 6.1
Ottawa: Ministry of Industry

Feng Hou and Larry S. Bourne (2004)
*Population Movement Into and Out
of Canada's Immigrant Gateway Cities:
A Comparative Study of Toronto,
Montreal and Vancouver*
Toronto: Statistics Canada, Business
and Labor Market Analysis Division

Barbara Kingsolver (2007)
Stalking the Vegetannual: A Roadmap
to Eating with the Seasons
Orion Magazine April/May

Lucia Lo, Valerie Preston, Shuguang
Wang, Katherine Reil, Edward Harvey,
and Bobby Siu (2000)
*Immigrants' Economic Status in
Toronto: Rethinking Settlement and
Integration Strategies*
Toronto: York University, Department
of Geography publication
ceris.metropolis.net

Elizabeth McIsaac (2003)
Immigrants in Canadian cities: census
2001—what do the data tell us?
Policy Options May

Christopher Picone and David Van
Tassel (2002)
Agriculture and biodiversity loss:
Industrial agriculture
*Life on Earth: An Encyclopedia of
Biodiversity, Ecology, and Evolution*
Niles Eldredge, ed.
Santa Barbara: ABC-CLIO

Ontario Food Terminal Board (2007)
Ontario Food Terminal Board
www.oftb.com

Ontario Ministry of Public
Infrastructure Renewal (2006)
*Growth Plan for the Greater
Golden Horseshoe*
Toronto: Ontario Ministry of Public
Infrastructure Renewal

Wayne Roberts (2001)
The way to a city's heart is through its stomach: Putting food security on the urban planning menu
Toronto: Toronto Food Policy Council

Vandana Shiva (2003)
Globalization and the War Against Farmers and the Land
The Essential Agrarian Reader
Norman Wirzba, ed.
Lexington: University Press of Kentucky

Statistics Canada (2006)
Annual Demographic Report 2005
Catalogue no. 91-213-XIB
Ottawa: Ministry of Industry

Statistics Canada (2001)
2001 Community Profiles:
Toronto CMA
Ottawa: Statistics Canada
www.statcan.ca

Toronto Food Policy Council (1994)
Reducing Urban Hunger in Ontario: Policy Responses to Support the Transition from Food Charity to Local Food Security
Toronto: City of Toronto Food Policy Council

Toronto Food Policy Council (1996)
Food Retail Access and Food Security for Toronto's Low-income Citizens
Toronto: City of Toronto Food Policy Council

Harold Troper (2000)
History of Immigration to Toronto Since the Second World War: From Toronto "the Good" to Toronto "the World in a City"
Toronto: Ontario Institute for Studies in Education, Joint Centre of Excellence for Research on Immigration and Settlement

United States Department of Agriculture (2006)
Potatoes: Background
Washington: USDA, Economic Research Service
www.ers.usda.gov

University of Massachusetts Amherst (2004)
Food and Farming Systems: Community Supported Agriculture
UMass Extension: Vegetable Program
www.umassvegetable.org

Melissa Watkins, Stewart Hilts, and Emily Brockie (2003)
Protecting Southern Ontario's Farmland: Challenges and Opportunities
Guelph: Centre for Land and Water Stewardship Publication, University of Guelph
www.farmland.uoguelph.ca

Evergreen
www.evergreen.ca

Farm Fresh Locator
www.gotothefarm.ca

Foodshare
www.foodshare.net

Growing Power
www.growingpower.org

Local Flavour Plus
www.localflavourplus.ca

Ontario Greenbelt
www.ourgreenbelt.ca

Vicki's Veggies
www.vickisveggies.com

global tastes
john feffer

Courtiers once collected special flavors for the famous banquets of the Roman emperors "in every corner of the Empire from the Parthian frontier to the Straits of Gibraltar" (Suetonius 274). The Chinese emperors, too, demanded a succession of unusual and exotic treats from distant lands opened up by the Silk Road. Today, this tradition still lives on, fitfully, in North Korean leader Kim Jong Il's requests for Czech beer and Italian pizza.

If we are what we eat, then emperors have been defined not just by bloodline but by diet as well. What good was it to have an empire if you couldn't "eat" it too?

The isolated Kim Jong Il aside, such distinctions between the imported exotica available only to royalty and the routine local fare of commoners have largely faded. What was once available only to kings and queens is now sitting on your local supermarket's freezer shelves. Food courts in malls throughout the world routinely offer European, Asian, and Latin American fare alongside such hybrids as Chinese Cajun (bourbon chicken) and Mexican Italian (jalapeño pizza). Exotic flavors such as pepper, nutmeg, vanilla, and pineapple are now commonplace.

Nor is this phenomenon confined to the industrialized world. Fast-food hamburgers bring the taste of America even to the lands of the sacred cow (where lamb substitutes for beef). The world's poorest subsistence farmers, losing their livelihoods to cheap agricultural imports, crowd into the cities where they eat foreign corn, wheat, and soy products that have often been chemically augmented. The global trade in foodstuffs has made cosmopolitan eaters of us all.

Exotic provenance alone no longer supplies sufficient added value to justify higher price tags. The declining terms of trade—by which raw materials such as agricultural produce have declined in value relative to manufactured goods—have affected producers and

consumers alike. The declining value of pork bellies and corn syrup and potatoes can barely keep their producers afloat, and the same market logic applies to more upscale choices like specialty coffee, cilantro, and Asian pears. In short, only products that are in scarce supply, such as truffles or kangaroo meat, escape being subjected to industrial-style production, scientific manipulation (such as genetic engineering), or just plain cross-border competition that drives down prices.

Whereas distance once conferred value on food as traders brought items from a land of abundance to a land of scarcity, the global market and ferocious price competition have largely eliminated that value. To maintain profit, the food industry has sought other methods of adding value to both raw and finished products.

The alchemy of the marketplace transforms this vulgar pursuit of profit into something more high-minded: a quest for distinction. To acquire this distinction, in Pierre Bourdieu's sense of the term, wealthier global consumers have drifted toward other designations to reinforce their sense of exclusivity. It is no longer enough to eat New Zealand lamb or Brazilian oranges in the wintertime. These products have become déclassé, much as sugar and tea lost their distinction as elite comestibles in the Middle Ages to become the mainstay of the British poor by the time of the Industrial Revolution (Mintz 148). Discriminating consumers, who want to show that they have *taste*—which is so much about asserting status and economic class—gravitate toward other marks of distinction. This campaign has also involved the transformation of "health foods" from flavor-challenged options—the lowly tofu burger—into flavor-enhanced superfoods full of vitamins, antioxidants, and omega-3 fatty acids. "Healthy" once battled "tasty" in the popular imagination. Today, as the advertisers for Healthy Choice frozen dinners remind us, the consumer doesn't have to choose.

The "organic" designation has for some time been one such attempt to push a certain class of food up the value chain. In this way, the industry has succeeded in getting a growing number of consumers to pay more for fresh produce and packaged goods. But as organic food goes mass market, higher-end consumers are looking for other distinctions. The "local food" movement, by turning the age-old relationship of value and distance on its head, is poised to replace organic as the value-added distinction *du jour*.

the taste of organic

The firm NRE World Bento produces organic box lunches for the Japanese consumer. The boxes contain organic rice and vegetables produced in California, humanely raised pork from Mexico, wild salmon from Alaska, and other staples of the organic trade. Although 90 percent of the product is sold to Japanese railway customers, the factory is not located in Japan or even in nearby China. Rather, NRE World Bento is located just outside of San Francisco in the mid-sized California city of Fairfield, not far from the Jelly Belly and Thompson Candy factories.

Two factors have determined the factory's location. One is the source of the raw materials. Japan simply doesn't produce the volume of organic rice, vegetables, and meat that World Bento needs. The company had to look elsewhere. Although the eel for the unagi bento makes a long round trip from China to the United States and back to Japan, most of the remaining ingredients are grown and raised in California. The free trade agreement between the United States and Mexico brings the cheaper Mexican livestock into World Bento's supply chain.

Ordinarily, given Japan's import regulations governing rice, the United States would be the last place that the company could

outsource. US growers have been trying to break into the Japanese market for years with little success. Herein lies the second factor: NRE Bento discovered a loophole in Japanese import regulations that permits a low tariff for imported rice if it is part of a product containing at least 20 percent non-rice ingredients.

The NRE World Bento story illustrates several interesting developments in the organic market. What was once largely a countercultural phenomenon geared to local consumption has gone mainstream. The market for organic food reached $23 billion in 2002. In many countries it is the largest growth sector in agriculture. In the United States, for instance, the organic market has grown by roughly 20 percent a year since 1997. This market has become attractive enough to lure Wal-Mart, which is poised to become the largest purveyor of organic produce in the country.

The international trade in organic products has also inexorably expanded over the years. Australia, Brazil, China, and several other key agricultural producers are aggressively marketing their organic produce. But demand continues to outstrip supply. One of the top three organic producers in the world, the United States imports eight times more organic food than it exports (Tringe, 2005). "Product shortages in North America and Europe are resulting in organic food imports from across the globe," according to *Organic Monitor,* which identifies China, Turkey, and Brazil as sources for beans and nuts; India, Paraguay, and Ethiopia for herbs and spices; African and Asian countries for fresh fruit and vegetables; and Latin America and Australasia for organic meat products.

In the food world, a packaged item like a bento box has a much higher profit margin than the raw materials alone. And so an international organic assembly line has emerged to produce and transform the inputs into finished products that can then retail at a much higher

price. To facilitate the creation of this assembly line, countries have begun to harmonize their regulatory and labeling mechanisms. Rather than being at cross-purposes, free trade and regulation go hand in hand. The contemporary food trade is only possible with certain quantifiable standards (health and safety requirements, quality assurances, and so on). Disputes continue, for instance between the United States and Europe over genetically modified organisms, but the general principle of harmonizing food trade standards endures.

This harmonizing process bears out one of the conclusions of Julia Guthman's penetrating study of the California organic sector, *Agrarian Dreams*: the organic movement has devolved largely into a practice of labeling. At the outset, the organic movement was not about adding value to products for upscale consumers. In the 1950s, J. I. Rodale was concerned about the sustainability of the soil. Only gradually, with the development of third-party certification, did organic become a marketable category. The more radical approaches to crop production, the reconfigured relationship with the consumer, and the more ecological understanding of overall sustainability have subsequently been overshadowed by the more easily quantifiable questions of regulation and marketability. This is how states and international regulatory agencies "see"—and thus organize, in James Scott's formulation—organic agriculture.

The love affair between high-end customers and the organic sector may well be brief. With the institutionalization of the production and distribution of organics—which enabled NRE World Bento to set up shop outside San Francisco, countries like Brazil and China to boost their exports of organic produce, and Wal-Mart to shoulder its way into the market—discriminating consumers are beginning to look for a different measure of authenticity.

Locavores—the latest trend in dietary activists—speak of reducing "food miles," of sustaining small farms, of the better taste of produce grown or raised locally (Feffer, 2007). It's not just Europeans. North Americans are beginning to follow the European lead in prizing local products. Local sourcing—with its application of the term *terroir* to products other than wine and the rapid growth of direct farmer-to-consumer marketing through consumer-supported agriculture (CSAs)—has taken up the same radical challenge to factory farming that the organics movement raised a generation ago, but with an additional critique of the global agro-assembly line. In a reversal of the old relationship between emperors and their dominions, people are nowadays assigning greater value to items produced locally.

Consider the various "eat local" challenges that have sprouted up throughout North America. In *Gourmet* magazine, environmentalist Bill McKibben chronicled his effort to survive a Vermont winter on root vegetables, canned tomatoes, and locally brewed beer. Ethnobotanist Gary Nabhan confined his year of eating locally to within 200 miles of his northern Arizona home where a rather narrow range of food can be coaxed from the landscape. The food service Bon Appetit conducts an annual 150-mile "eat local challenge" at its cafés in universities and corporate campuses across the United States. Further north, a Canadian couple spent a year eating a whole lot of potatoes in the 100-mile circle they drew around their Vancouver home (www.100milediet.org). And, in his latest book, *The Omnivore's Dilemma,* food writer Michael Pollan set the bar even higher by defining local as no further than hand's reach, as his progressively more demanding effort to eat off the land culminated

with a meal of wild pig that he shot, wild mushrooms that he gathered, lettuce that he grew, and fruit that he gleaned.

At the moment, the locavore movement seems impervious to the institutionalization that has afflicted organics. Production for local consumption is by definition small-scale. A certain amount of added value can rise up through the food chain: the local farmer charging more for the local tomato, the restaurateur charging a little more for the local tomato salad, the consumer willing to pay extra for something that has a local "distinction" attached. But such a value-adding exercise by definition stops at the boundary of the defined "local space," whether it is 200, 150, 100, or 50 miles. True, "local" Vermont maple syrup or Pittsburgh microbrew or Memphis barbecue sauce can be produced and marketed on a large scale, and these products derive much of their value from their specific locale. But the "eat local" purist is not interested in someone else's local food. The local designation is not comparable to a Codex Alimentarius geographic designation—basmati, champagne, kimchi—that *facilitates* trade. The movement is designed to discourage trade because trade pushes producers to greater economies of scale.

Does the consumer, by buying local, acquire distinction in the same way that the Chinese emperor did by consuming Samarkand peaches or the upscale shopper does by buying organic plums at Whole Foods? The "eat local" movement has reversed the value-distance equation. It becomes the poor who are condemned to eat the cheap food in the supermarket—white bread produced several states away, frozen orange juice from Brazil, sandwich meat from hogs butchered in Mexico. The wealthier consumers demonstrate their extradietary concerns—whether expressed in the desire to reduce overall consumption, help small farmers, or improve their own health with less-processed food—by paying a little more for

locally produced products, whether vegetables or microbrewed beer or bread from a local bakery. This process of creating value, often arbitrary, is inescapable in our economic system. When locavores praise the flavor of a locally grown tomato, they are asserting that taste—as opposed to merely the calories needed to sustain life—is important. They are privileging their own tastes, their own health, and the socioeconomic assumptions embedded in these choices.

Although the eat-local movement will, by its very think-small nature, resist the institutionalization that the organic sector has experienced, it may nevertheless fall into the same value-laden trap. Like the organic politics of Whole Foods, the eat-local phenomenon may devolve into a simple pocketbook issue—which vegetable, the locally grown or the imported, costs less?—and its fundamental critique of food production will remain largely rhetorical. If it stops evolving into a political movement and instead devolves into a mere consumer movement, eating local will become little more than a set of distinctions to distinguish one type of product and one type of consumer from another, and another opportunity to change the world will be eaten away by the exigencies of the market.

Pierre Bourdieu (2002)
Distinction
Cambridge: Harvard University Press

John Feffer (2007)
The challenge facing local food
Salon, January 18
www.salon.com/mwt/food/
eat_drink/2007/01/18/eat_local/

Global Organic Food Industry Facing
Supply Challenges (2006)
Organic Monitor
www.organicmonitor.com/r1511.htm

Julie Guthman (2004)
Agrarian Dreams
Berkeley: University of California Press

Bill McKibben (2005)
A Grand Experiment
Gourmet, July

Sidney Mintz (1986)
Sweetness and Power
New York: Penguin

Gary Nabhan (2001)
Coming Home to Eat
New York: Norton

Michael Pollan (2006)
The Omnivore's Dilemma
New York: Penguin

James Scott (1988)
Seeing Like a State
New Haven: Yale University Press

Suetonius (1981)
Life of Vitellius
The Twelve Caesars
New York: Penguin

James M. Tringe (2005)
U.S. Market Profile
for Organic Food Products
USDA, Foreign Agricultural Service
(FAS), February

The Big Apple
Colborne, Ontario

photo: Claire Ironside

apples
to
oranges
claire
ironside

The Orange Julep
Montreal, Quebec

Your food travels an average distance of 2,414 kilometers to get to your plate, which is a large part of the reason every calorie you eat takes an average of 10 fossil fuel calories to produce.*

A look at the fossil fuel inputs of a locally grown, organic apple, and a California orange, both destined for the Toronto market, reveals the difference.

*Dr. Joseph Pimentel, Cornell University professor of ecology and agricultural science.

Colborne to Toronto
178 km

Colborne

Toronto

Orange County to Toronto
5,632 km

Orange County

Toronto

Fossil fuel inputs
of a local, organic apple

organic local
farming
8%

commercial
preparation/storage
9.5%

bulk packaging
9.5%

retail storage/
maintaining
6%

preparation/
manufacturing
22%

transportation
2%

home storage/
cooking
43%

Fossil fuel inputs
of a Californian orange

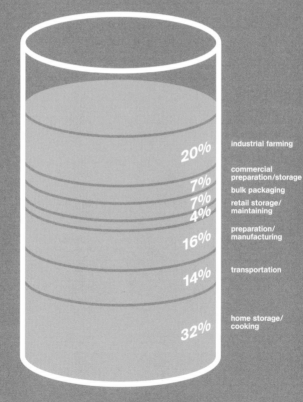

industrial farming

commercial
preparation/storage

bulk packaging

retail storage/
maintaining

preparation/
manufacturing

transportation

home storage/
cooking

20%

7%

7%

4%

16%

14%

32%

Total fossil fuel footprint of a local, organic apple compared with average

APPLE FOSSIL FUEL FOOTPRINT
1:8

**Total fossil fuel footprint
of a Californian orange
compared with average**

ORANGE FOSSIL FUEL FOOTPRINT
1:12

foodshed:
the globalized infrastructure of the ontario food terminal
pierre bélanger
angela iarocci

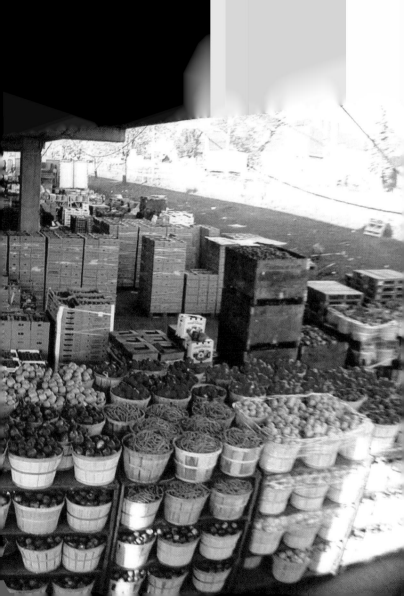

The 2003 blackout in the US Northeast and Central Canada offered dramatic proof that many cities in the developed world carry no more than a three-day reserve of fresh food. As more and more of the 6.5 billion people who inhabit the planet move from the country into the cities, critical concerns are being raised about the fragility of our food systems. Are we prepared for the reality of mass urbanization?

Global manufacturing industries, in response to the rising pressure of urbanization, have set up just-in-time delivery systems that are able to move enormous quantities of food to urban consumers. These industrial systems are in constant motion, transporting foodstuffs from mega-farms on several continents to city centers thousands of kilometers away.

As public awareness of the globalization of the food supply system has increased, resistance is also on the rise. Activists campaign for greater reliance on local food sources, asking consumers to be mindful of food sustainability and to support regional farm economies. But these strategies are likely to have only marginal impact on our eating habits as long as the supersize discount outlets, with their economies of scale, are able to entice customers with lower prices. Retail giants such as Costco and Wal-Mart already dominate most suburban areas and are constantly extending their reach, creating one new store every single day across the Americas.

Over the last half century, food delivery systems in large urban centers, although largely overlooked by planners, economists, and politicians, have undergone a critical transformation towards keeping the retail giants from gaining complete control of the food supply system. The changes began in the years right after World War II, when a sudden, massive influx of immigrants escalated the demands placed on food supply systems. A comprehensive reorganization of the food industry in North American cities was needed.

In those decades, the 1940s and 1950s, Keynesian economic policies and Fordist modes of production were creating an entirely new urban infrastructure. The rapid expansion of North America's highway system, combined with the advent of refrigeration, made mass-market food delivery systems possible. These systems required centralized transport and delivery hubs for the wholesale distribution of perishable fruits and vegetables, and the modern food terminal emerged to answer that need. These terminals—mostly public-private ventures—had four main objectives: to relieve traffic congestion in city centers, centralize exchanges between growers and buyers, institute food quality standards, and regulate prices— moderating the predatory business practices of the large, vertically integrated retail food chains (as early as the 1920s, chain stores were biting off a solid 30 to 50 percent chunk of the food sales market across the continent).

In the past fifty years, twenty-five of the largest metropolitan areas in North America have built food terminals. Each city operates at least one central facility, imposing quality controls, serving large, ethnically diverse populations, and keeping the playing field level for wholesalers. Since the advent of the North American Free Trade Agreement in 1994, Canada has moved past Japan and Europe to become the United States' number one trading partner in fruits and vegetables. This expanding cross-border trade, as well as another wave of immigration to the Great Lakes region over the past decade, has exerted new pressure on the continental food system. Ensuring sustainable, perpetual production and a stable, year-round supply of fresh produce—everything that everybody needs, including fruits, fish, and flowers—becomes a more complex operation with each passing year.

Most manufacturing in the US and Canada has been in decline over the past few decades, but the food industry has been growing as fast as other sectors were collapsing: it is now the most important manufacturing sector in North America, second only to transportation. Including spin-offs in food handling, processing, and packaging, agricultural production is now a trillion-dollar-a-year industry that employs more than one-fifth of the North American population.

At the center of this explosive growth, located in one of the fastest-growing metropolises in the Western world, is the Ontario Food Terminal (OFT). The OFT is the biggest wholesale distribution node for fresh food in Canada, and the third largest in North America, after those of Los Angeles and Chicago. Operating at a breakneck pace 365 days a year, the market has not shut down for a single day since its opening in 1954. Over a million tonnes of produce travel through it every year, making it one of the most important terminals in North America—a food commodities stock exchange that can never stand still.

Referencing Walter P. Hedden's 1929 milestone book *How Great Cities Are Fed*, the following pages tell the story of the operative landscape of the OFT to describe the magnitude of the urban foodshed, a term that designates the network of food production and distribution across a region—and to better understand a model of the flexible and resilient urban infrastructure big cities will need if they are to achieve food security for the twenty-first century.

The OFT was created in response to a crisis in Toronto's wholesale market operations in the mid-1940s. The rapidly growing population of immigrants from Europe and China was placing significant new demands on the city's infrastructure. Market warehouses were bursting at the seams and transport vehicles had a hard time getting through the traffic congestion to the

downtown markets. While the St. Lawrence Market had served the city well since its modest beginnings as a distribution center in 1803, the new, larger delivery trucks had rendered streets impassable and the market had now clearly outgrown its footprint. The post-war economic boom had created an urgent need for modernization.

Terminal Optimism: Sketch of the U-shaped terminal proposed in 1954 by architects Phillip Shore and Robert Moffat.

On May 17, 1952, the Wholesale Fruit Market in downtown Toronto was destroyed by fire. Faced with a choice between rebuilding on the site or moving the market to a new location, the city opted to take the operation west. Provincial Minister of Agriculture Thomas L. Kennedy argued for paving over a 162,000-square-meter (forty-acre) Etobicoke swampland. Conveniently situated between two major roadways and a trunk line, the site had plenty of space, with room to expand. Building was temporarily set

back by postwar steel shortages, but the Ontario Food Terminal was finally opened on July 1, 1954. It was the first wholesale food terminal of its kind on the continent. Farmers in Ontario now had a new home, allowing them to compete with the international distributors who trucked fresh farm produce into Toronto from as far away as California and Mexico. So successful were the operations of the terminal that less than a year later it had reached full capacity.

Ontario Food Terminal, 2006.

The terminal works as a leveler. An arm's-length govern-mental organization operating on the principle of just-in-time delivery, it ensures fair market competition. The terminal especially benefits small and medium-sized businesses that have strong demand for produce but limited storage and handling capacity. They need fast turnaround times and fresh goods daily. The terminal aggregates 3,100 independent grocery stores, 1,172 franchise stores, and over 600 growers and farmers in Southwestern Ontario. The site houses a farmers' market with 550 stalls and a warehouse market with 7,500 square meters of cold storage and 1,400 square meters of dry

storage. It is equipped with a 575-car parking deck, two
cafés, and a restaurant. Like a miniature city, it even has
its own centralized garbage collection and police force.
All of this production takes place in an environment of
totally flexible circulation, where every horizontal surface
is dedicated to movement and every enclosed space to
storage; nothing can afford to remain static. Everything in
the terminal has two functions: buyers double as unloaders,
jobbers as go-betweens, and farmers as cashiers. Even the
underbelly of the double-decker main parking lot doubles
as an overhead canopy for the farmers' market.

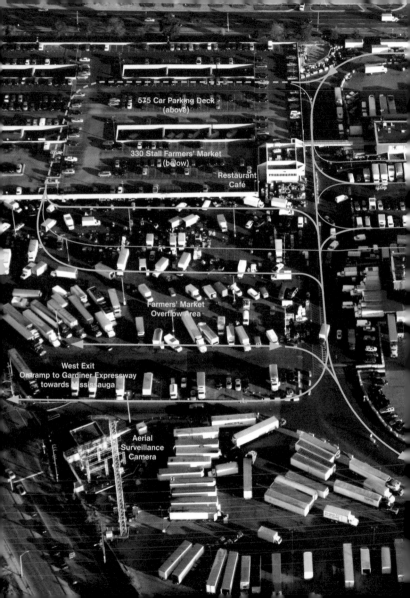

575 Car Parking Deck
(above)

330 Stall Farmers' Market
(below)

Restaurant
Café

Farmers' Market
Overflow Area

West Exit
Onramp to Gardiner Expressway
towards Mississauga

Aerial
Surveillance
Camera

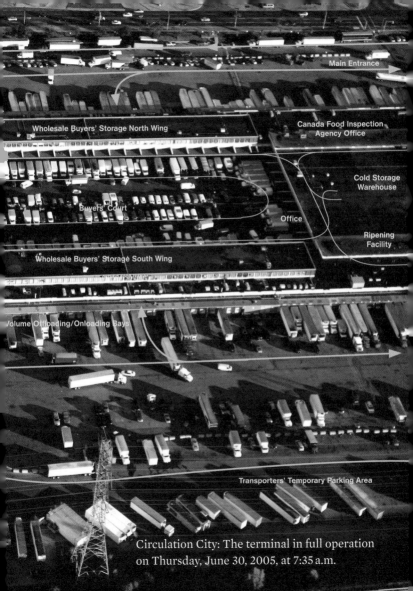

Main Entrance

Wholesale Buyers' Storage North Wing

Canada Food Inspection Agency Office

Cold Storage Warehouse

Buyers' Court

Office

Ripening Facility

Wholesale Buyers' Storage South Wing

Volume Offloading/Onloading Bays

Transporters' Temporary Parking Area

Circulation City: The terminal in full operation on Thursday, June 30, 2005, at 7:35 a.m.

Des__e its chaotic appearance, OPT traffic is extremely organized and thoroughly standardized. The scalar breakdown of vehicle types and sizes provides evidence of their origin and their route: large eighteen-wheel transports bring produce from distant farms via transcontinental highways, one-ton cube vans belonging to large wholesalers come in on main expressways, and small mini-vans from mom-and-pop corner stores arrive through

Terminal operations during the mid-summer harvest season, Thursday, August 10, 2006, at 5:30 a.m.

City streets. At ground level are the go-betweens, whose diversity reflects the immigrant pool in the Greater Toronto Area. These OFT employees are the critical link between buyer and seller, transporting goods around the terminal in motorized mini-forklifts at speeds up to 40 km/h. The terminal's organization is like its architecture, essentialized and circular.

The loop of the terminal is entirely closed. Nothing is wasted: any food unsold at the end of the day is donated to the city's largest food banks, cardboard containers are recycled, wood pallets are reused, and the sludge and

sweepings are composted; everything flows back into the system. Entirely self-supporting, the terminal finances its own operations through its base cash flow and leases, without a single government subsidy.

The one part of the terminal's operations that remains remarkably inelastic is its tenancy system: the thirty-year leases held by the most powerful grocers in the city are renewable in perpetuity, privileging a small number of family-owned businesses that have kept a tight hold on their

terminal rights for over three generations. The business is so robust, and the leases so sought after, that each one is estimated to be worth over a million dollars in annual economic returns.

In its role as a regulator, the terminal has helped support the rise of local independent grocers and growers since the 1970s, even as the number of retail chains has decreased from 24 to 13. The OFT has indirectly contributed to the growth of greenhouse operations throughout Ontario, which has the fastest-growing concentration of greenhouses in North America. Greenhouse operations in Leamington, Ontario, are doubling their production every five years. The terminal also functions as a generator.

Spin-off effects include more than 600 companies, ranging from food processors and packagers to customs brokers and freight forwarders, that employ over 40,000 people. Fueled by diverse demand from Toronto's 347 documented ethnicities, the OFT serves the largest, most important manufacturing sector in the city, and has established a unique and irreversible connection with all levels of the food system: metropolitan, continental and global.

Multiplier Effect: Constellation of food and beverage companies concentrated in proximity to the OFT.

CHOCOLATE *Signatures*

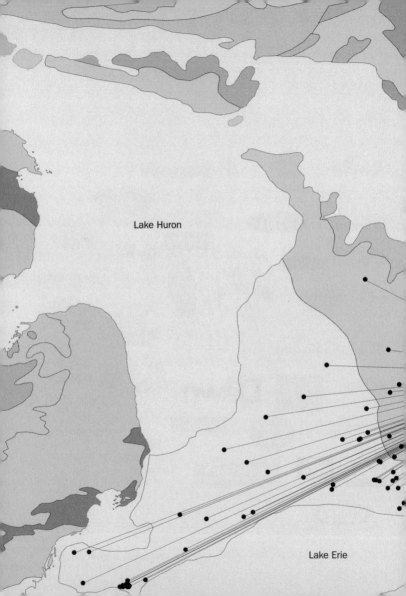

Lake Huron

Lake Erie

Geo-Economics:
The distribution of official growers and wholesale buyers in the Southwestern Ontario Region, according to soil types and regional climates.

Lake Ontario

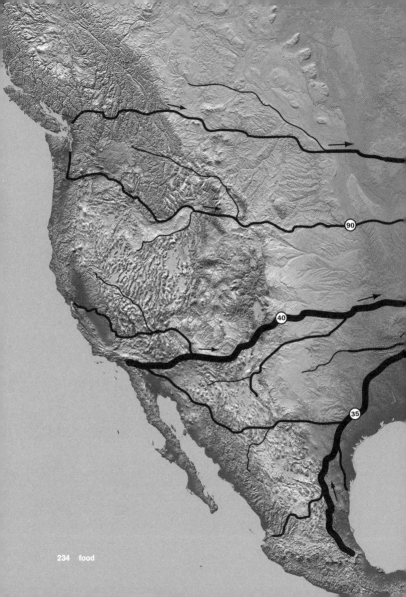

**Urbanization of the Food Chain:
The extent of the Ontario Food
Terminal's outsourcing network
based on the North American
highway network.**

pierre bélanger, angela iarocci 235

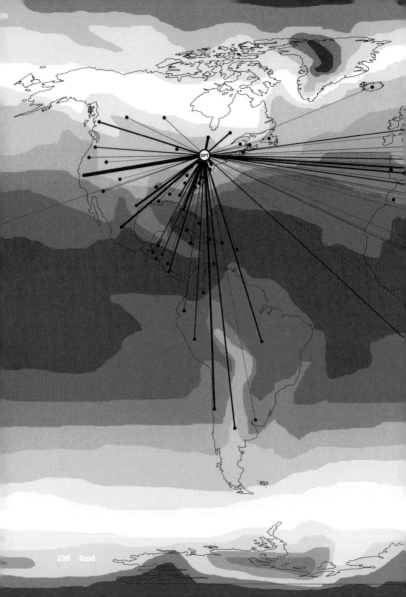

Global Foodshed:
Food sources and proportional
flows of distribution according
to global temperature variations.

There is virtually no end to the operations and to the reach of the terminal. Highway access flattens out geography, enabling the terminal to reach deep into the Southern United States and Mexico, making California and Monterey —land of blueberries and mangos—Canada's best friends during the cold dormant winters. As a total ecological inversion, the map of global temperatures speaks more to the cyclical variation of goods than to the bio-climatic boundaries of natural systems.

As the critical infrastructure between buyers and sellers, the OFT supports more than 3,100 independent grocery stores, 1,172 franchise stores, and over 600 growers and farmers in the Southwestern Ontario region. The OFT is at the nexus of a region with more than 7 million hectares (18 million acres) of Class 1 arable land, the most fertile and productive region around the Great Lakes, supreme in the agricultural food sector in Canada, along the longest, most undisputed border in the world. So competitive and so robust is the structure of the terminal that even the retail food chains, which largely dominate other North American cities, supplement their distribution chains with produce from the OFT.

Fully extended, crossing over into any country at any time, the OFT's elastic infrastructure upsets the classical Malthusian principle that food scarcity must result when population increases. The terminal's most essential characteristic is its ability to expand and contract according to global seasons and market prices. Three cycles of distribution are made apparent by the map of global temperatures: during the summer, goods come from local sources in the Southwestern Ontario region, during late fall and early spring from continental sources in the Southern US and Mexico, and during the winter from international sources as far away as Argentina, Australia, and South Africa. Creating a global foodshed that is co-dependent on temperate and tropical produce, the Ontario Food Terminal is evidence of a robust, cosmopolitan trading system, strategically designed as one of the most sustainable networks of food distribution in the history of the New World.

seeds
of the city
harriet
friedmann

illustration by james totolo

At an Ethiopian restaurant in a not-yet-fashionable district of Toronto, a microcosmic moment reveals how culinary and agronomic cultures live in many places at once. Our hosts pass a pan of freshly roasted coffee to delight our noses. Then they brew it over a small flame in a richly carved container next to a pot of smoking frankincense. The ritual preparation merges taste and smell, and the coffee seems to taste of frankincense. One of our group, Anan Lololi (originally from Guyana), is an organizer of community gardens and the AfriCan food box, which delivers weekly boxes of culturally specific ingredients for African-Canadian cuisines to the African diaspora. He disappears into the kitchen to investigate the herbs that flavored the dishes we had enjoyed. Could Toronto gardeners grow them? He emerges with a hopeful smile.

Coffee was first domesticated in Ethiopia, and its wild relatives can still be found in that extraordinary center of biological and cultural creativity. It traveled to Europe via Arabia three hundred years ago, where the first coffee houses (for men only) created sensation and scandal. Political opponents of the English monarchy, for instance, gathered to share passions and gossip, their "coffeehouse discourse" eliciting fear and scorn from the elites.

Then it was introduced in the Americas and later Asia as an export crop, entailing familiar colonial and neo-colonial exploitation of people and ecosystems. An African berry that reached the New World by a roundabout route through the Middle East, Europe, and then Asia, cultivated by African slaves in the Americas, coffee, with sugar, was one of several colonial stimulants that changed the world. Coffee made it profitable for Europeans to transport slaves and indentured laborers across oceans to work plantations and transform ecosystems and cultures.

Coffee became cheap. Consumed in every workplace in North

America by the twentieth century, it eventually became the drug of choice of late capitalism. In the past twenty years the export imperative has accelerated international competition and driven down prices for coffee growers all over the Global South, as far away as Vietnam. Coffee is now a niche beverage in the North, which translates into a bewildering array of espressos, lattes, flavors, and countries of origin.

Yet in a Toronto restaurant people who have never been to Ethiopia are able to experience a continuity of ancient coffee culture, from bean to preparation and taste. Centuries of cultivation have not destroyed the (agri)culture of coffee in its place of origin.

Still, Ethiopian coffee production, which has flourished as an essential part of social and cultural relations for thousands of years, could finally succumb to monoculture. Mixed farming systems everywhere face international and industrial competition and polycultural peasantries are being uprooted by political upheavals. In a global enclosure of the remaining peasant farming systems of the earth, we risk the cultural and biological diversity that for millennia has provided not only coffee, but all the crops on which humans depend. In this sense, coffee served in traditional ways by Ethiopians in diaspora is emblematic of a wider and deeper displacement.

From its beginnings, colonial rule transplanted people, plants, and animals across the earth. The goal was often monocultural plantations. Yet people carry their cultures with them wherever they go. Diasporas have always intersected with each other and with indigenous people to create new gardens and cuisines.

This is the secret history of colonialism. Almost all North American food crops are transplants. Even maize, except for the decorative varieties displayed at Thanksgiving, originated in Central America, not the north. The many cultural groups who immigrated by force

or by choice have always carried familiar seeds and animals with them. They created the food cultures we now experience by naturalizing familiar food species in the gardens and cooking pots of the novel ecosystems they encountered. They created new polycultures in all senses, learning from native peoples and cultural groups arriving from many parts of the world how to grow and cook and appreciate new foods, including the plants that are the ingredients of their cuisines.

Diasporas have always been biocultural. Even in the direst situations, humans traveling in domestic groups have carried the seeds they knew. African women captured and sold into slavery concealed precious seeds in their hair, close to the farming knowledge inside their heads. Other migrants, under different degrees of duress, carried food crops to new places where they encountered evolving cultural complexes of humans and their foods. These meetings of cultures created entirely new cuisines, adapting and mixing both ingredients and techniques.

Indigenous American, African, Asian, and European influences combined in myriad ways in the Americas. I grew up in the 1950s with a distinctive local cuisine, now a rarity in the United States, based on a continuous peasant tradition that went back two hundred years. The Cajuns of the Mississippi Delta in Louisiana are similar to the syncretic cultures of the Caribbean, although they are usually seen as descended only from Acadians expelled from Canada in 1755, when England won one of its colonial wars against France. Their cuisine, however, is much more diverse than elite New Orleans haute cuisine, which can be traced back to aristocrats fleeing the French Revolution to the French colony of Louisiana (named for the king and queen of France). These wealthy settlers brought their cooks as well as their jewels, furniture, and clothes, and adapted their indulgent

menus to include the crawfish, rice, and other delicacies provided by nature, slaves, and peasants in the colony. By contrast, Cajun cuisine, with its farming, hunting, trapping, and fishing, is an amalgam of African, Spanish, and indigenous influences, as well as a unique French culture: the Acadians, who had already adapted to the harsh climate of New France. They were joined a generation or two later by refugees from the Haitian Revolution of 1791–1804, who contributed yet another new mix of French, African, and indigenous cultures.

It was only adaptive polycultures that enabled colonial settlements to survive at all. Beginning in 1721 a two-year famine devastated the 7,000 Europeans and 2,000 enslaved Africans of the first Louisiana colony. The Europeans who followed them survived by adapting their tastes. Wheat had been transplanted to the Spanish colony of Veracruz, Mexico, but supplies were unreliable and it was too costly to import. Instead, a unique agriculture emerged from the crops and cultures of West Africans and New World indigenous peoples. The Pascagoulas were among those who had long traded maize, beans, fruit, vegetables, and meats with the first French fort, in exchange for manufactures. The Houma joined them, learning to raise poultry (first domesticated in Asia, via Europe), though they would not eat the birds. Most slaves from West Africa were already familiar with maize, which had been introduced in the early years of the slave trade, and had become a staple food of the indigenous peoples throughout the Americas. Some West Africans also had long experience with a distinct species of African rice, and Louisiana's colonial governor requested that slave traders bring slaves with prior knowledge of rice cultivation. Slave cooks in the colony used maize and rice interchangeably in a dish called couscou—a French term, borrowed from the native Moluca tongue, which was later applied to a very different dish in France's North African colonies.

By the 1760s Africans and Native Americans were matter-of-factly sharing both crops and horticultural skills. These Creole ties altered power relationships as well. Some enslaved West African women from food marketing societies used their skills in the slave colony to earn enough to buy their freedom.

The polycultural invention continues, as new circumstances bring new immigrants into changing international economic and political contexts. As an immigrant child I ate my mother's Hungarian cuisine, adapted to the ingredients available in Louisiana, and also delighted in visiting a local community of Hungarian strawberry farmers. Other farmers and cooks were expanding the (agri)cultures of Louisiana. Visitors to New Orleans in the twentieth century would be invited to eat a muffuletta sandwich, of Sicilian origin, as part of the local cuisine of the French Quarter. Eventually the irresistible, highly spiced gumbo (an African word) and jambalaya (whose name is obscure but possibly Spanish or indigenous), along with native alligator (rescued from extinction) have traveled to cities throughout North America. Cajun restaurants may be next door to those from Ethiopia.

And still it continues, almost hidden from view in the relentless march of monocultures, which continue the dominant history of colonialism. Familiar North American landscapes of cows and wheat, like the meat, milk, and bread they provide, have much shallower roots than ancient Ethiopian coffee or postcolonial Cajun shrimp farming. Superficially those vast farm fields appear more productive and economically more sustainable than Ethiopian or Cajun farms. North American grain and livestock feed the world, including regions in South America, Asia, and Africa, where they have displaced traditional native plants and cuisines. These enormous food factories supply ingredients for the industrially produced edible commodities that have become the cuisine of late capitalism. Fast food displaces

cultural creativity, just as endless vistas of maize and soy displace more diverse, smaller-scale farming systems. Now Mexicans toiling in fields of tomatoes destined for American or Canadian hamburgers have neither the land nor the time to make tortillas, nor (in new circumstances) money to buy them. Instead they buy dehydrated "Chinese" soups.

Yet Ethiopian coffee is prepared with frankincense in Toronto, and gardeners from many parts of the world experiment with Ethiopian herbs in the city's polycultural gardens. The creativity that has always coexisted with monoculture continues. Now it is carried by the largely urban people who are migrating in ever greater numbers to Europe and North America from Africa, Asia, and South America.

As the last wave of destruction sweeps away the peasantries of the Global South, the possibility arises that not enough farming cultures will survive to ensure that human-guided evolution of food crops and livestock will continue in their places of origin. Some of those displaced peasants—farmers, many cooks, and some trained agronomists—will move to global cities. They are keepers of the seeds and skills specific to the ecosystems and cultures they came from. They often see these seeds and skills as "traditional," meaning that they lack commercial or social value to the larger neo-European society. Yet their cuisines are embraced by the wider society in restaurants and appropriated by supermarkets as standardized "ethnic" cuisines. This raises the possibility of reforging the links of each food culture in new settings, reaching right back to the soil—in gardens and on rooftops. The context is no longer, as it still was even a hundred years ago, one of an indigenous culture being suppressed and crowded out by a colonial complex of crops and people. Now it is one in which food cultures must be intentionally preserved, adapted, and changed. The new polycultural possibilities depend entirely on conscious action.

Biocultural diasporas have intersected in the Americas since 1500. Today's immigrants are better able to maintain close ties to home than previous generations were. They are at once more attuned to familiar tastes and more open to mixing elements of familiar cuisines with those encountered among neighbors. Less visible is the adaptation by local farmers to changing tastes by reviving old domesticates (e.g., goat for Caribbean dishes), revaluing weeds (called callalo by Jamaican cooks), or adopting new cultivars (such as ginseng or Ethiopian herbs). As farmers age, it seems logical to renew agriculture with a new generation of immigrants who are able to connect more directly with changing cuisines. Still, most immigrants come from cities and settle in cities: urban neighborhoods and community gardens are potential sites for mutual learning, as seeds are shared and agronomic knowledge exchanged among immigrant cultural communities.

Toronto has the double gift of a kaleidoscope of cultural communities with gardening, farming, and cooking skills from many recently intact (agri)cultural systems, and a network of community and municipal organizations that initiate and coordinate citizen involvement in local food systems. Local government plays a key role in fostering exchanges. The Toronto Food Policy Council is within the municipal Public Health Department. Its paid staff coordinates the work of a volunteer council of stakeholders, including local farmers. It advocates for policies including farmland preservation (now beginning through the Greenbelt surrounding the city), wholesale and public markets for local farmers, community gardens, community-run, publicly supported school meal programs, and much more. FoodShare Toronto is a non-governmental organization closely associated with TFPC.

Two projects of particular interest here focus on the mutual learning of cultural groups about growing and cooking. FoodShare

was an early participant in the heritage seed movement. In addition to selling seedlings of traditional plant varieties each spring, the organization has hosted seed-sharing events and workshops to teach about them. A coordinator was amazed when conventional farmers showed up, worried about their future as government technical advice to farmers, which had existed in the US and Canada since the nineteenth century, was scaled back in favor of seed packages, complete with instructions, from private corporations.

FoodShare's three-year Seeds of Our City project, coordinated and documented by Lauren Baker, brought together dedicated gardeners from many countries, including, among others, China, Ghana, Jamaica, Sri Lanka, and Vietnam, to learn how to grow each other's foods, and to increase their familiarity with plant varieties from other parts of the world. The gardeners kept meticulous records in a standard format. They simply recorded what they already did, making their observations systematic and accessible to the other gardeners, so that their knowledge could be preserved and shared. In partnership with an urban environmental organization and AfriCan, the largest culturally specific food box program, Seeds of Our City had sites throughout urban and suburban Toronto. The project organized visits among gardeners, bringing people together to exchange stories, meals, produce, and seeds.

Biocultural diasporas can, as they have in the past, increase the diversity of food plants. Thus the Northern contribution to the indispensable politics of preserving the sites of origin of food plants, which are mainly in the Global South, may be the conscious adaptation of cultivars in urban sites where people increasingly dwell. This suggests a rethinking of agronomic education and research: instead of surviving in the interstices of monocultural farming and control over seeds, I can envision cooperation in which scientific research

includes—and enhances—the knowledge of farmers, and farmers help to define research agendas and participate in experiments of scientists. Let us call them farmer-scientists and scientist-farmers. In any case, agronomic and culinary creativity has always been the secret history of colonialism and specialized trading regions. Bringing it to the foreground may be the key to saving what humans grow and eat.

zwischenstadt
905
wayne roberts

photographs by chris thomaidis

When Roger Keil looks north from Toronto's CN Tower, he sees more than just pavement smothering Canada's best farmland. Keil, the new director of the City Institute at York University, sees somewhere in between the past and future of a world that's urbanizing so fast that it has created a new species of cityscape.

Directly beneath the Tower, the tallest freestanding piece of cement in the world, Keil can see the old downtown core, established when the economy's lifeline to the outside world was a harbor on Lake Ontario and a rail line that brought goods to it. How many Torontonians remember that Bay Street is so named because the economy carried real things to a real bay, not a virtual bay of global stock and money exchanges? Probably about as many as those who know that almost all the world's cities are built on prime farmland, because historically that was how cities fed themselves and grew.

Beyond the hustle and bustle of a dense downtown that mixes homes and businesses with cultural and civic centers—the kind of mix that helped create Toronto's reputation as "the city that works"— lies a ring of streetcar- and then auto-linked suburbs, and then another ring of small cities that are struggling to hold on to some kind of center, and beyond that a fringe, a jumbled mess of land and buildings apparently organized on the same housekeeping and design principles as a teenager's bedroom. This is the area most Torontonians identify by its telephone exchange, 905, not by any definable feature of its natural or built landscape. Keil sees in this "archipelago of disconnected enclaves" a future that just might work. He calls this zone "the in-between city," translating *Zwischenstadt,* a term coined by the renowned German planner and architect Thomas Sieverts. This could mean the zone between Barrie and Toronto, between urban and rural, betwixt present and future, or between cities and survival.

Keil studies such backdoor entrances to the world's metropolitan cities, a new phenomenon of the built environment that is growing at an explosive rate. It is seldom talked about except as the butt of comments about vulgar sprawl. But, he tells me, a plurality of the world's people now live and work in just such in-between areas, and, contrary to the out-of-date stereotype, most of them are have-nots compared to downtown haves.

York University, where Keil works, was built during the 1960s on former farmland on the edge of Downsview, which, local history buffs insist, once commanded a beautiful view. It's a great place to think about the past and future of the in-between city. Like most of Toronto's booming outer edges during the 1950s and 1960s, Downsview was what Keil calls a "Fordist suburb," a place where working people could pay for their own homes by working in nearby factories, both built on low-cost farmland—a virtuous economic circle of a perverse kind. Fordist suburbs were distinct from the "bedroom communities" we now think of as exemplifying suburbia, which in the 1950s and 1960s were the territory of executive types who drove downtown to make the money they spent in the outskirts. That difference between then and now is why today's de-industrialized Fordist suburbs face such problems with poverty and its frequent byproduct—of much more concern to the media and politicians—crime. In 2001, Toronto's Food and Hunger Action Committee described the paradox confronting these areas, which are in greater difficulty than the urban core, but whose dire situations are commonly overlooked because poverty and crime are still typecast as "inner city" problems. The suburbs, said the committee, have "downtown problems without downtown services."

During Keil's daily bus ride to York, he gets to study post-Fordist Downsview as it merges with the new in-between city. The visuals

This is the area most Torontonians identify by its telephone exchange, 905, not by any definable feature of its natural or built landscape. Keil sees in this "archipelago of disconnected enclaves" a future that just might work. He calls this zone "the in-between city."

that tell him he is entering the in-between are the juxtapositions of university/pioneer village/nine-acre urban farm/box store/utility corridor/oil tanks/plaza/aircraft factory runway/upper-income white neighborhood/low-income black neighborhood/expressway—the kind of jumble that would never be part of traditional suburbia. The hodgepodge is the message, the indicator of the new urban species Keil is tracking.

Keil's perspective first took shape in his native Germany, where he worked as a planner for Frankfurt's Green Party administration. Frankfurt has a relatively small and compact downtown of about 600,000 people, but, much like Toronto, it has attracted four and a half million more people, who live in its suburbs and outskirts—making it Germany's second-largest metropolis as well as a transport and trade hub. Trying to develop a greenbelt plan for that historic city "inspired my method of understanding the production of urban landscapes," Keil says. "I came to see landscapes as in process of evolution, as the debris of history, the sediment of past forms of production and consumption." That's the urban archaeologist who can see backwards and forwards from the CN Tower.

An important influence on Keil's thinking was Thomas Sieverts, one of the first Europeans to treat the sprawl beyond city outskirts as more than an abomination. It was in a 1997 book, translated as *Cities Without Cities,* that he introduced the term *Zwischenstadt.* Both Keil and Sieverts are struck by the stark contrast of in-between and traditional suburbs, where zoning enforced the strict separation of permitted commercial uses and people. "Everything here is highly splintered," says Keil. "There are contradictions and juxtapositions you never found in the suburbs which were known for conformity and sameness. What's new is the togetherness of contradiction. It's a type of urban morphology that's different from thirty years ago, and

the new planning has to correspond to the change. There are huge opportunities to think more creatively."

Keil, a member of the City of Toronto's Environmental Round-table, is most keen about linking urban design with social justice and environmentalism. I first met him in my Greenpeace days, shortly after he moved to Toronto in the early 1990s, when he joined a weird in-between-style juxtaposition of the time—a joint initiative of Greenpeace and the auto workers' union to convert a closed tractor factory into a production line for solar water heaters. The in-between city gives scope to Keil's social as well as environmental thinking. He smiles as he notes that it's now the gentry who live in the inner city. The old migration out of the inner city used to be about well-employed workers and professionals "fleeing the city to escape the lower class," he says. This is no longer so in the post-Fordist era. Today's out-migration is about working and professional families "escaping from the upper class and unaffordable housing in the downtown."

What about environmental sustainability and self-reliance in the twilight zone of the in-between city? As global warming reconfigures the world's access to food, water, and energy, the in-between city may get some respect. In the near future, water for food production will be scarce, fossil fuels will be too expensive to devote to synthetic fertilizers and pesticides, the transportation of vegetables and fruit across oceans and continents will be costly, and just-in-time supply lines will be vulnerable to disruption from the spread of new diseases. City planning for self-reliance in food basics thus takes on a new urgency, which is what places the in-between city in the foreground of responsible urban planning.

The in-between city is loaded with unused capacity to rise to the challenge. Orphaned land, acres of open space in the middle of

"There are contradictions and juxtapositions you never found in the suburbs which were known for conformity and sameness. What's new is the togetherness of contradiction. It's a type of urban morphology that's different from thirty years ago, and the new planning has to correspond to the change. There are huge opportunities to think more creatively."

no rhyme or reason, is waiting to be used for orchards and gardens. It's accessible, and just the right size for low-tech sustainable agriculture and aquaculture, the intensive kind that produces plenty of food per square foot as well as lots of jobs and ecological benefits, such as the cleansing and revitalizing of air and water. In-between farmers, in other words, will provide precious ecological services as well as food.

Think of assets, not problems. Box stores and parking garages have flat roofs that can take the weight of all-season greenhouses. Both residential and commercial areas produce tides of soapy "gray water," now wasted but rich with both water and key fertilizer elements that can be adapted for agriculture. There's no shortage of humanure that, carefully composted, could regenerate exhausted soil. And the distance between producer, processor, distributor, and an archipelago of diverse customers is ideal for low-energy, high value-added, high-efficiency businesses. The in-between city is as close as we'll ever get to near-urban agriculture, which is one of the chief ways that cities of the near future will be feeding themselves.

Keil says it's time to stop dissing and start re-examining the area. "There are crown jewels here, but we can't see them," he says, "because they're ugly."

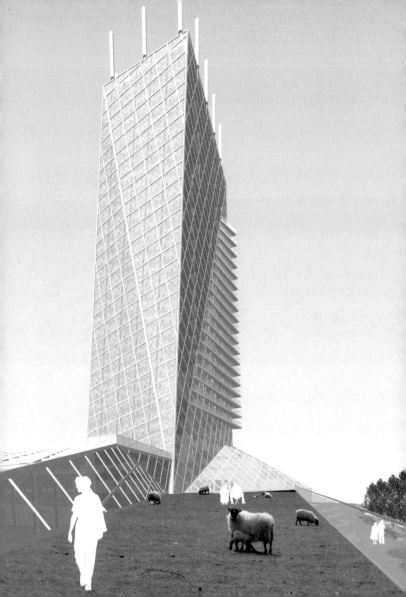

farm city
chris hardwicke

Cities have two footprints on the land: their actual urban footprint, and an ecological footprint that extends far beyond the urban, suburban, and agricultural areas surrounding them. As urban sprawl grows to consume valuable agricultural land, agricultural lands in turn are increasingly encroaching on sensitive wilderness ecosystems. Farm City proposes a new kind of architecture that would enable cities to feed themselves by creating agricultural areas inside new housing towers. By combining living and growing space in a dense vertical format, Farm City reduces the need for sprawling suburbs, eliminates food travel distance, and creates a living architecture that is part of an urban ecosystem. Farm City allows urban dwellers to be responsible for the production of their food: to be farmers or gardeners. Farm City is a place where we can watch our food grow and take delight in our own sustenance.

Take Toronto as an example of the effects of urban sprawl: like most large modern cities, it has an enormous environmental impact. The estimated ecological footprint of Toronto extends over an area more than 280 times its size. By the year 2015 the area is expected to increase 55 percent even without an increase in population (Onisto et al.). Of that ecological footprint only 20 percent is created by housing. The majority of the footprint comes from food (31 percent) and transportation (23.9 percent).

Worldwide, over 38 percent of the total landmass of the earth (800 million hectares) is used for agriculture. In the next 50 years, the world population is expected to rise to at least 8.6 billion, which will require an additional 10 billion hectares of agricultural land. That quantity of farmland is not now available.

Traditional farming has transformed our landscapes from wilderness to fields for crops and herds, and has devastated ecosystems through erosion, pollution, and clearing. Although contemporary agricultural practices undeniably contribute to our good health and longevity, it is becoming more and more apparent that they are creating new health hazards on an unprecedented scale. Traditional agricultural practices that use significant amounts of agrochemicals such as pesticides and fungicides present significant risks. Agricultural and urban encroachments into natural areas have increased the incidence of emerging infections: respiratory diseases, influenza, rabies, yellow fever, malaria, and others.

The Farm City Energy Cycle

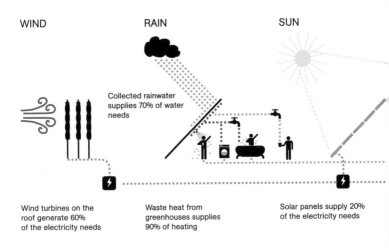

WIND

RAIN

SUN

Collected rainwater supplies 70% of water needs

Wind turbines on the roof generate 60% of the electricity needs

Waste heat from greenhouses supplies 90% of heating

Solar panels supply 20% of the electricity needs

Farm City proposes that we bring food production back into the city. Keeping our food production where we live would allow us to oversee our own agricultural practices and ensure that they are safe. It would also stop the further encroachment of agricultural lands into our wilderness, and allow our forests and wetlands to regenerate. These ecosystems are not only great natural resources, but are essential to creating clean air and safe drinking water, as well as reversing climate change.

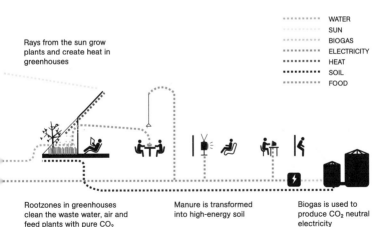

Rays from the sun grow plants and create heat in greenhouses

········· WATER
········· SUN
········· BIOGAS
········· ELECTRICITY
■■■■■■ HEAT
■■■■■■ SOIL
········· FOOD

Rootzones in greenhouses clean the waste water, air and feed plants with pure CO_2

Manure is transformed into high-energy soil

Biogas is used to produce CO_2 neutral electricity

Indoor farming is not a new idea. Tomatoes, strawberries, and a wide variety of herbs have been grown in greenhouses for years. Urban farming is not a new idea either. People have always grown food in backyards, community gardens, and vacant land within cities. Farm City is the vertical extension of urban agriculture, using greenhouse technologies. It creates more area for growing and allows apartment dwellers access to gardens.

By locating housing and farms in the same building, Farm City creates symbiotic relationships between energy, water, and waste. Heat generated from the greenhouses is used to heat the housing units. Biomass from the greenhouses is used for energy. Solar energy is generated from the large glazed surfaces. Gray water and compost generated from the housing are used in the greenhouses. Most important, it makes food production part of our culture by making gardens visible and allowing us to participate in our own sustenance.

—William Elsworthy, Chris Hardwicke, Mark Juhasz, Vivien Lee, Hon Lu, Deborah Wang

Lawrence J. Onisto, Eric Krause,
and Mathis Wackernagel (1998)
How Big Is Toronto's Ecological Footprint?
Centre for Sustainable Studies and City of Toronto
www.toronto.ca

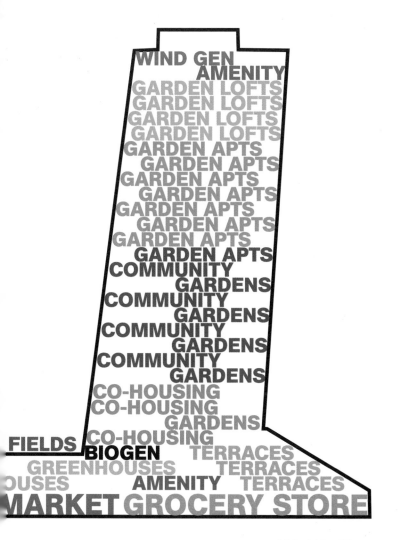

WIND GEN
AMENITY
GARDEN LOFTS
GARDEN LOFTS
GARDEN LOFTS
GARDEN LOFTS
GARDEN APTS
GARDEN APTS
GARDEN APTS
GARDEN APTS
GARDEN APTS
GARDEN APTS
GARDEN APTS
GARDEN APTS
COMMUNITY
GARDENS
COMMUNITY
GARDENS
COMMUNITY
GARDENS
COMMUNITY
GARDENS
CO-HOUSING
CO-HOUSING
GARDENS
CO-HOUSING
FIELDS BIOGEN TERRACES
GREENHOUSES TERRACES
OUSES AMENITY TERRACES
MARKET GROCERY STORE

what a city could taste like
katie rabinowicz andrea winkler

Waves of immigration in the eighteenth and nineteenth centuries brought itinerant European street vendors and their customers to North American cities. Hawkers and peddlers sold peanuts, popcorn, homemade candy, cashews, candied apples, Turkish delight, fresh fruit, and a variety of other foods. These salesmen fed the development of cities, complementing their infrastructure by taking low-cost food and goods to the new arrivals in the streets where they lived and worked.

So why, in so many cities, is there now such a dearth of street food? Essentially, it is because street food moved indoors. Modern planning segmented the city into specialized areas. The sidewalk, once a place for vending, socializing, and political activity, was declared off limits for anything but pedestrian circulation. Cooking and eating became private, indoor activities, and the sale of food became the domain of specialized retailers. At the same time, street vendors themselves became more upwardly mobile; they acculturated, bought or rented stores, and moved inside. The street lost its public culinary life.

Vendors now operate either illegally or in limited numbers in limited areas of North American cities. Strict laws covering what may be sold and where are either couched in euphemistic terms of "beautification" or "urban renewal" or explicitly target vendors, panhandlers, and street entertainers. Vending regulations that claim to work in the public interest may in practice be used against certain groups: uncoordinated or vague rules lead to ad hoc and selective enforcement. Such "street cleaning" has particularly affected women, visible minorities, and people with low incomes who rely on the sidewalks for their livelihood or cultural expression. When these groups are removed from the streets, they are cut off from their spaces of employment. Consumption and recreation become more exclusive.

Urban renewal strategies in Toronto and Washington, DC, for example, led to police crackdowns or increased restrictions on vendors. In Toronto, vendors were removed from Chinatown and Yorkville, slicing off some of the city's space for low-income employment and consumption. In Washington, policies presented as neutral had the effect of disproportionately reducing the number of women vendors. The new regulations mandated increased licensing fees that the lower-income women could not afford, heavy carts that many women could not maneuver, and a smaller and more widely spaced vendor population that was not as safe for women vendors. In Atlanta, vending had been an important entry point into the formal economy for those facing barriers to employment, including a segment of the city's black population. Black street vendors supplied their own communities with the goods they preferred and contributed to a local black culture and public realm. These traditions were ignored by the new vending regulations.

For some communities, illegal or informal vending is either an economic necessity or an act of rebellion against a regulatory system that is blind to the impact it has on the lives of women, minorities, and people with lower incomes. The law in many cities is indifferent to the legitimate and beneficial ends of this extralegal vending, including stronger immigrant entrepreneurialism, a more accessible public realm, a means to distribute cheap goods to poor people, and simple survival for people who may have no other way to make a living.

Defiant vendors are flouting the law everywhere. In Toronto, street food is theoretically limited to hotdogs (provincial health regulations limit food preparation to "the reheating of precooked meat products in the form of wieners or similar sausage products to be served on a bun"), but you can still find a summer student selling crepes outside a health food store, a Peruvian woman selling

contraband empañadas in the market (she now owns an empañada restaurant), a man selling corn on the cob on a major shopping strip, and a community kitchen selling baked goods in the local park. In Oakland, California, where the Latino community established rows of illegal fruit stands and taco trucks along major thoroughfares, the city eventually legalized their informal economy as a tool for economic and cultural development.

These initiatives show what cities could taste like. Street vending could be a highly adaptable delivery system, tracking the cultural tastes of cities' increasingly diverse populations, and bringing healthy, safe, affordable foods to appreciative customers, wherever they are. Vendors add a nimble, mobile element to a city's food system, and can quickly adapt to changing tastes. With their low overhead costs and local roots, vendors can create and serve markets for good, locally grown and prepared food specialties.

If regulations were liberalized, vendors could sell a wider variety of foods and there would still be public health inspectors to visit carts and ensure they were clean and safe; vendors would still be trained in safe food handling. New York has a great variety of street food because the city's rules apply to the cart, not the food. Vendors' carts must be stored at an approved facility where they are inspected and serviced at regular intervals. Philadelphia has a similar system; when vendors apply for a food license, they specify the kind of food they propose to sell and the health department inspects their vending units accordingly.

A coordinated vending policy is needed in many cities and could be developed through meaningful public consultation with vendors, consumers, planners, and others. One of the aims of such a policy should be to support vending as viable employment for those facing barriers to employment or looking for an entry into the formal

economy. Cities could provide business training, offer more vending licenses, set aside districts where informal vending would be permitted, and support vendors' organizations.

Urban spaces could be designed specifically for vendors and their customers, for example, by providing washrooms nearby, safe spaces for women vendors, and comfortable public areas for sitting, eating, and socializing. According to Nisha Fernando, flexibility is the key: "rather than repeating the same design of sterile unused streets, leaving space for spontaneous and culture-laden street life has the potential to generate an exciting public social life in our cities. The focus must be on making urban streets flexible to their users under regulations other than those that overspecify land uses and apply strict zoning codes, so that users of different cultures can then modify, add to or change the streets in ways appropriate to their society and culture."

With the health of urban societies, multicultural expression, and public life increasingly at issue, contemporary North American cities have an opportunity to renew one of their most vital original economies. Street food presents an opportunity to break from the usual planning practices, which often take a siloed approach to public space, focusing on zoning and narrowly defined land uses. A revival of street vending could help inform a new vision: the creation of a public realm that is supportive of cultural and employment diversity, healthy food, and tasty living.

Nisha Fernando (2005)
Taste, Smell and Sound on the Street
in Chinatown and Little Italy
Architectural Design May

behind
the mall
diana
shearwood

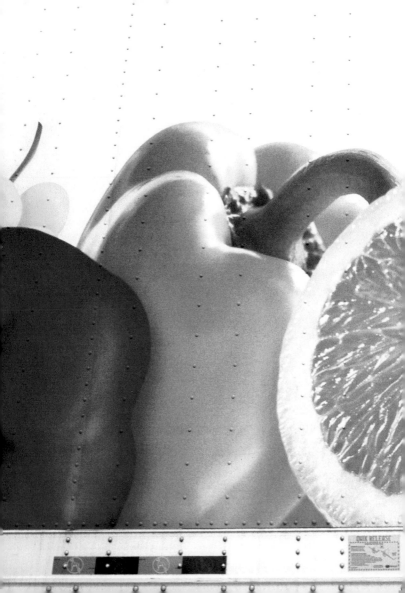

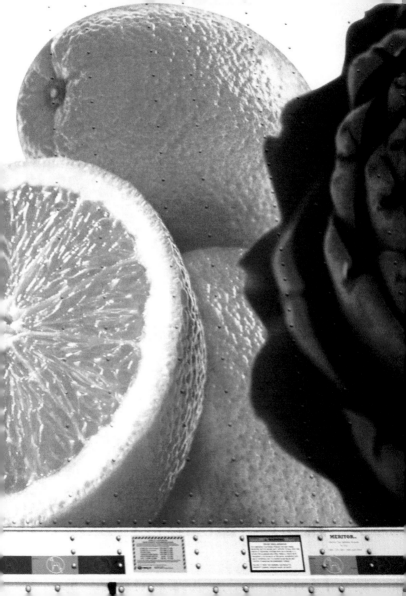

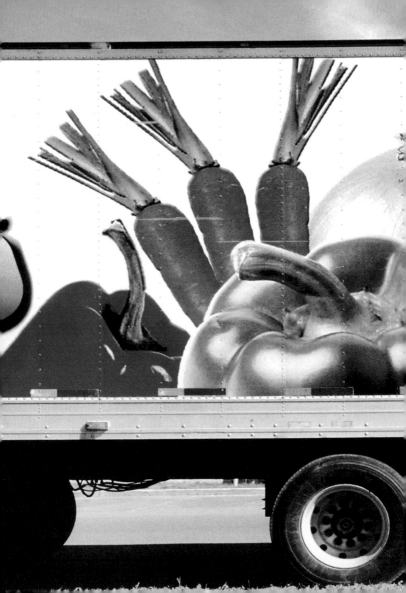

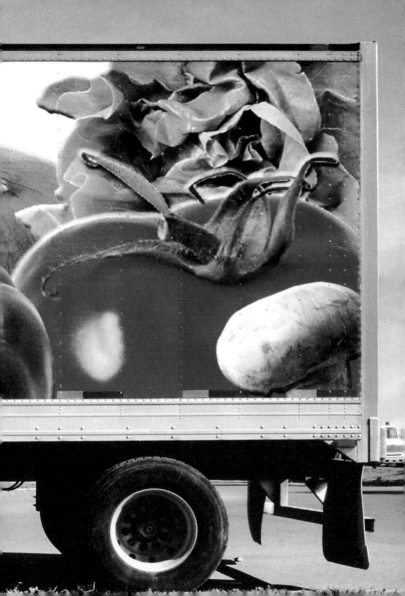

cafeterias, a memoir
nyla matuk

photographs by chris thomaidis

By accident, by convenience, or by necessity, I have been attached to cafeterias all my life: they are an institution as much as any school; a caretaker by another name.

grade school, ottawa, 1973

On the first day of grade one, I ran out the door with the other children at recess time with my Raggedy Ann and Andy lunchbox. To my horror, I discovered that it was not lunchtime at all. It was recess, and the Ann and Andy thermos had leaked its soup contents, wetting the sandwich and other food. As I sobbed, one of the teachers led me, along with the spoiled lunch, to an empty cafeteria where the janitor skated a mop across the floor. The room was indifferent. It offered no recompense. My lunchbox had betrayed me, and I faced an imminent horror: a noon hour with bad food.

the salvation army grace hospital cafeteria, ottawa, 1975

My mother left me to fend for myself while she visited her patients.

The servers—ladies wearing hairnets—looked at me as if they had reached the end of a long journey. Then their focus would shift suddenly to the food in front of them. They slapped scoops of mashed potatoes onto my plate with quick pragmatism while the dishwashers behind them removed dirty dishes from the conveyer belt. Some days, their intense stares seemed to ask me not what I wanted to eat, but something urgent and indecipherable about another time and place.

I was both anonymous and all too conspicuous. I felt the dreadful fact of my brown wool duffel coat—the color of Irish stew—a loathsome entity in the ocean of blue and green scrubs, of crisp, nursey whites. There were no other children: I sat alone. I learnt how to pour milk without incident, filling a glass or a miniature box of Kellogg's Rice Krispies. I cultivated other, equally important formalities at the hospital cafeteria—the provision of cutlery, the polite borrowing of a bottle of ketchup, the ordering of an omelet with cordial brevity; stoicisms of a kind. They served me well in later years in other cafeterias, automats, and buffet-style restaurants.

a room filled with vending machines, third floor, ottawa public library

As a child I spent the summers at the library, in lieu of camping or a month by the sea. When my antihistamine had worn off in the afternoons, I wandered to the vending machines drowsily, after a nap taken on the large multicolored snake-shaped pillow that lurked in the children's reading room. The little plastic roll-back doors on the machines showed a *Rear Window* view of waxy Red Delicious apples, tins of fruit or rice pudding, ham and Swiss on rolls, cheese and crackers. Looking at them, I saw the promise of a rapid blood sugar high beckoning, a midnight snack that was not one.

I remember striking up one or two conversations with a plump girl named Carla who lived on Bell Street. We would stare into the machines and wonder how they worked. The whole room—this vending machine hangar—was joyless, a kind of machinated feedlot for readers. A real cafeteria, alive with the sound of trays on railing and the choice of more than one type of cream pie, is resplendent and rococo compared to this.

In one corner of the room, a circus of half-sleeping wasps over a garbage pail butted heads like dopey bumper cars.

national post cafeteria, toronto, 1998

Our cafeteria was the site of lunches during days spent entirely indoors. Here, my company president was vulnerable too, as if for a time he'd landed on earth. The lineup felt like a limbo line, and never a thought given to the layoff that I would one day suffer, a downsizing. It was foreshadowed during a reverie, perhaps upon a stodgy "Luau" lunch of sliced ham and pineapple.

The functional design of cafeterias—the rounded corners of the metal railing, or the red lights of the roasters—is a heavily guided series of ingresses. As with a parking garage, there is no opportunity to misstep; its wayfinding markers are definitive and final. Moving into the space, you encounter familiar, martial rows of sandwiches under duress, their sweet pickles captured under clingy plastic made shinier by the neon overhead. There is also the armada of dessert items and small-plate salads. On your tray, as you move yourself to the eating area, the Jell-O cubes jiggle brightly, complacent in their semi-transparency.

That Jell-O is cold comfort in a place that can make you believe that it is always nighttime.

Some cafeterias are uncanny: they are both familiar and strange. Situating itself next door to the train station in the city of Nice, France, where I alighted from a night train recently, tired and hungry, "Flunch" offered a microwave oven in the middle of the dining area for reheating items that had cooled during the cash register lineup, a separate entrance for its ice cream parlor, a small non-smoking area, and a horse-meat entrée. In France, birthplace of the idea of refinement in perfume, cookery, and garments, a pudding under a cling wrap at Flunch can be adorned with *chantilly* (whipped cream).

And how do you come to a decision here? The choices will present themselves over and over again until you are released from the wheel of rebirth that is packaged food. And despite the repetition it is comforting, because you choose all the things you want; amongst the clutter and the trays and cutlery, the two-veg options, and the lunchtime lineups, choices are always made in a hurry.

Who cared about sunshine, who cared about hail? It was in a cafeteria, by the hum of refrigerators, that I learned I could eat alone.

the memory of taste

maria zajkowski

The Memory of Taste

At the table Dorotka says
the ham reminds her
of first days, school,
lunch among the green
uniformed children
while father grimly
from the shadow end
says he smells burning
bodies two miles off.
He was the one running,
running from the sound,
the taste, the ash on his face.
Dorotka says she can't eat.
This is today and father
is rough, deep-boned
and pungent with the memory
of a wide summer sky
blooming with death.

Cardiac Simplicity

I was happy my father did not dig for a living. In one summer on one
 day when I sat on his knee,

(though it could have been you or no one at all), he sliced up the orb
 of a swede and we ate it on

a white chair over the concrete.

It's a long way from that year, I was even wearing a dress,
 unheard-of for little Marysia

who fought with sticks for rifles and beat, beat, beat the long grass
 in the big field down

out of her way. Around and around I paced through the days,
 addressing trees,

questioning plums—"Why are you a plum and I am not one?"

I'd ask it in English, somehow in Polish and sometimes in Maori
 when I was alone.

In the complicated language of plants there was no answer for me.

The rough Slavic hands of my father were, I suppose, like so
 many others,

but only his considered my mouth worth a donation, and this,
 for a Catholic, shouldn't

be much. The child of a Catholic I was, and just a child anyway,
 probably four.

For my father first it was the war and then me. I am not still small
 and on his knee, though if I

were we would need nothing as he would explain how to cut
 from a swede

the size of a heart, the weight of a heart; "one for you and one
 for me."

The Facts

This is called rain. You stay in. Sometimes it rains forever. The tide comes in and washes you away. The tide returns you to your post. Your girlfriend says *do something* when you think you already are. When you are looking for a job the rain will remind you of her. She wants to go out. She wants entrées, mains, and dessert. You love her expression, the angle of her head when a squid has given itself up for her. She kisses it into her mouth and chews it so kindly, marveling at the flavor. It rains. You want to fly to Rio, she loves to dance. Even in a tsunami you would think of her hips, the sexiest metronome you've seen. When she is raining you try to keep dry, you think she can be dry too—*just stop raining, darling*. Your own dam has that near-trembling surface, that close-to-breakingness, that's your emotional meniscus. She leaves every day and comes back. And you? Have you checked that the grass is still waving? What did the birds do this afternoon? Is there still a sun? She wants to know the facts, not about drowning or the love you want to keep in buckets. This is rain, it stains paper. It falls again and again. You wake up again and again. Ants come in to see how it is and make use of an old glass of water. To hear their feet you look harder. Is this the same glass you had when you were four? Are these ants following you? Who are you anyway sitting at the bottom of yourself translating rain? *Do something,* she says, so you lick the drops from your lips, and later, as needed, hers. You tell her the birds say sorry for not going with her to work. You are sorry too for not having more flavor. She wants entrées, mains, and dessert and chews *you* kindly. The fact is that you will more than well do.

scenic cookery sian bonnell

contributors

Dean Baldwin is represented by Katharine Mulherin Contemporary Art Projects, Toronto (www.katharinemulherin.com).

Pierre Bélanger is a landscape architect at the University of Toronto.

Sian Bonnell is an artist based in the UK. www.sianbonnell.com

Sophie Bouy is a Toronto-based photographer and designer. www.sophiebouy.com

Mei Chin is a fiction writer and food critic living in New York City.

Christine D'Onofrio obtained an MFA from UBC in Vancouver, where she currently practices.

Rebecca Duclos and **David Ross** collaborate under the name Graphic Standards.

Fallen Fruit is a Los Angeles-based activist art collaborative; it's members are David Burns, Matias Viegener, and Austin Young.

John Feffer is the author of several books and the co-director of Foreign Policy In Focus.

Harriet Friedmann teaches sociology at the Munk Centre for International Studies, University of Toronto.

Chris Hardwicke is an associate at Sweeny Sterling Finlayson & Co Architects.

Jennifer Harris teaches English at Mount Allison University.

Angela Iarocci teaches in the York/Sheridan Joint Program in Design in Toronto.

Claire Ironside is a designer and teaches in Sheridan College's School of Animation, Arts, and Design.

John Knechtel founded Alphabet City in 1991.

Lei Bo is from Taiyuan City, Shanxi Province, China. He is a Ph.D student of Chinese Thought and Intellectual History in the Philosophy Department of Peking University.

Jane Levi combines studies in food history with her day job in the City of London.

Nina-Marie Lister teaches in Urban Planning at Ryerson University and is a principal of pLandform Studio.

Nyla Matuk's poems are in the archive at www.greenboathouse.com.

Katie Rabinowicz and **Andrea Winkler** are co-directors of Multistory Complex.

Wayne Roberts, PhD, coordinates the Toronto Food Policy Council.

Diana Shearwood is a Montreal photographer who documents abandoned motels, monumental silos, and food trucks.

Ann Shin is a writer and award-winning filmmaker based in Toronto. www.fathomfilmgroup.com

Chris Thomaidis is a commercial photographer based in Toronto. www.thomaidis.com

James Totolo is an illustrator working in the third dimension.

Maria Zajkowski currently lives in Australia and writes personal landscapes.

editor
John Knechtel

art direction + design
The Office of Gilbert Li

managing editor
Jennifer Harris

commissioning editors
Stephen Andrews
Pierre Bélanger
Daniel Borins
Heather Cameron
Mark Clamen
Karen Connelly
Roger Conover
Rebecca Duclos
Atom Egoyan
Dorothy Graham
Janna Graham
John Greyson
Chris Hardwicke
Mark Kingwell
Mark Lanctôt
Pamila Matharu
Lisa Rochon
Joseph Rosen
David Ross
Natalie Shahanian
Jim Shedden
Ann Shin
Camilla Singh
Timothy Stock
Kevin Temple
Sonali Thakkar
Mason White
Ger J. Z. Zielinski

festival coordinator
Joe Liu

copy editing
Doris Cowan

prepress + proofing
Clarity

legal representation
Caspar Sinnige

contact
alphabet-city.org
director@alphabet-city.org

thank you
Paul Bain
Marion Blake
Diana Fitzgerald Bryden
David Carruthers/PlanLab Inc.
Annping Chin
Jason Globus-Goldberg
Adina Israel
Heather McNabb
Lauren Wickware

next issues
Fall 2008
no. 13: FUEL

Fall 2009
no. 14: WATER

Fall 2010
no. 15: AIR

FOOD was made possible
by the support of:

METCALF FOUNDATION

**The Ontario Arts Council's
Chalmers Arts Fellowships**

DRAKE HOTEL

**ONTARIO ARTS COUNCIL
CONSEIL DES ARTS DE L'ONTARIO**

Canada Council
for the Arts · Conseil des Arts
du Canada

CLARITY

pcwf
PHOENIX COMMUNITY WORKS FOUNDATION